PRENTICE HALL Englewood Cliffs, New Jersey 07632

Jane H. James

West Valley College
Saratoga, California

2nd edition

perspective
drawing
A POINT OF VIEW

Library of Congress Cataloging-in-Publication Data

JAMES, JANE H.
 Perspective drawing.
 1. Perspective. 2. Drawing—Technique. I. Title.
NC750.J25 1987 742 87-17406
ISBN 0-13-660416-1

Editorial/production supervision: Lisa A. Domínguez
Cover illustration: Jane H. James
Manufacturing buyer: Ray Keating
Page layout: Debra Toymil

© 1988, 1981 by Prentice-Hall, Inc.
A Division of Simon & Schuster
Englewood Cliffs, New Jersey 07632

Printed in the United States of America

10 9 8 7 6 5 4 3 2

ISBN 0-13-660416-1 01

Prentice-Hall International (UK) Limited, *London*
Prentice-Hall of Australia Pty. Limited, *Sydney*
Prentice-Hall Canada Inc., *Toronto*
Prentice-Hall Hispanoamericana, S. A., *Mexico*
Prentice-Hall of India Private Limited, *New Delhi*
Prentice-Hall of Japan, Inc., *Tokyo*
Simon & Schuster Asia Pte. Ltd., *Singapore*
Editora Prentice-Hall do Brasil, Ltda., *Rio de Janeiro*

contents

10 reflections 230

conclusion 246

Perspective Drawing: A Point of View is written for everyone who wants to draw or paint images of the real world in a convincingly representational manner. Its purpose is to give an understanding of the principles of perspective drawing and the procedures for using them with as many shortcuts as possible. Here we attempt to answer the most asked questions and help the reader avoid many common errors.

This is a visual approach to learning perspective drawing, and it is designed to be a self-paced learning tool. Photos and drawings bridge the gap between the visual experience of living in a three-dimensional world and representing that world on a two-dimensional surface. Line drawings in series demonstrate methods, and self-tests with answers help the reader to understand concepts.

Those who are familiar with the first edition will find this edition much richer in terminology and depth of information. We have also made some design changes to clarify the book's intent and make it more convenient to use. The format remains much the same: each chapter starts with uses or esthetic purposes, governing principles, and needed vocabulary. Self-tests on concepts have answers at the end of each chapter. As each chapter proceeds, so does its complexity; in order that the reader may go as far as is appropriate in each chapter.

Deep gratitude is expressed to the many people who have contributed to this book with their help, encouragement, enthusiasm, and questions. A special thanks goes to Robyn Kline for her expertise, patience, and persistence in preparing line drawings for publication. Contributing photographers are Paul Dileanis, Steve Peltz, Claire Calcagno, William H. James, and Jane H. James.

This book is dedicated to all my students with whom I continue to learn.

J. H. J.

perspective
drawing

1

an
introduction

WHAT IS PERSPECTIVE?

Perception is uniquely personal, and its communication is an intimate gift of self, a gift that defines and characterizes the human species. Drawing is the oldest recorded means of this communication and probably is the clearest and most personal, even among today's multiplicity of sophisticated communications. Perspective drawing is certainly not new; its history and the formulation of its rules are very well documented, and its use in Western culture is clearly understood. Although many drawing purposes do not require perspective, it is a very important option, and its study provides an enriching means of perceiving the world, drawing its images representationally, or making intentionally expressive use of distortion.

The word *perspective* has various definitions: viewpoint, point of view, the point from which you view, one view of the world. Perspective drawing is one of many useful approaches to drawing. Its principles form the basis for the representation of distance in the visual world and the placement of shapes in distance. Most freehand drawing is done by eye, but it may help your eye if you understand the underlying principles of perspective drawing.

We use our sight to help us move around in our three-dimensional world, and through it we receive a constantly changing series of views of spatial relationships—that is, objects as they relate to each other in space. But in most drawings we are capturing a *single* view from a *particular* place and are using perspective drawing to create the illusion of three dimensions on a two-dimensional surface—one view of the world.

HOW TO USE THIS BOOK

Perspective Drawing: A Point of View is intended to acquaint the reader with the basic principles of prespective drawing and to provide practice in using them. Chapters start with basic concepts and self-tests, the answers for which appear at the end of the chapter; as more concepts are applied, the complexity increases. In this way each reader can proceed as far as is appropriate in each chapter. A study of the complete book provides a thorough grounding in the principles of perspective and enough practice to make concepts a part of permanent knowledge. Later, the book may be used as a reference for an occasional perplexing problem.

Knowledge of perspective is as important to the artist as is knowledge of drawing tools and materials. Only when perspective is understood do you have the choice of whether to use it, when to use it, and what kind of perspective or perspective distortion best serves your expressive purpose. It can be an intellectual game in which the parts fit together like a puzzle according to a set of rules, or it can be used as a group of principles that enhance understanding and expression of forms

in space. The creative artist chooses to use it, distort it, or ignore it on the basis of what it can contribute to the spirit and purpose of the work at hand.

The rules of perspective should be your tools, not your master.

TYPES OF PERSPECTIVE

In a broad sense, *perspective* means any creation of a three-dimensional illusion on a two-dimensional surface. To many people this term means *linear perspective*, which is what this book is about; however, there are many other kinds of perspective as well, which can be used singly or combined to enhance the perspective effect. Here are some you will recognize.

Overlapping

When one form partially hides another, it is in front of the other—closer to us—implying distance, or a spatial relationship. This relationship is called overlapping. The forms might be touching, or there might be miles between them, but we know that the one in front is closer. Overlapping is particularly useful in suggesting shallow space or very little distance between forms, as in overlapping pieces of paper or cards on a table where there are few if any other clues to distance. However, overlapping is also used to express deep space—as when you see one mountain range overlapping another—or in middle distance when you see buildings, trees, cars, and people overlapping.

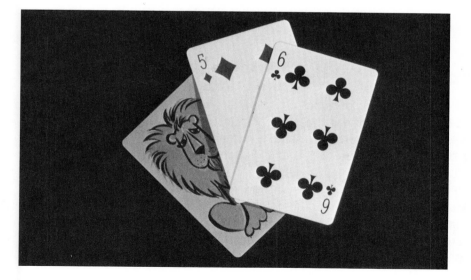

FIGURE 1–1

Modeling or Shading

A gradual change from dark to light within a form, is another way of showing depth or three-dimensional quality; it is called modeling or shading. Modeling is useful in showing the distance between the front and the back of a rounded form. Look at this piece of fruit. Without its modeled shadow, it might be a flat circle instead of a sphere—quite a difference in three-dimensional quality!

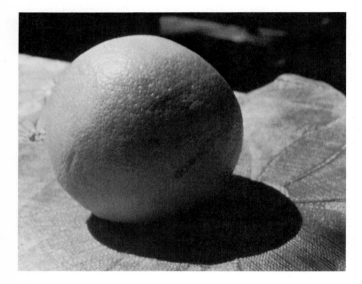

FIGURE 1–2

Color Perspective

The relative warmth and coolness of two or more colors produce color perspective. Generally, warm colors are those associated with warm physical experiences: yellow, orange, and red are associated with sun and fire, and we speak of them as being "warmer" than blue, violet, and green, which are associated with water, grass, and shadows. We may sometimes speak of a "cool" red, however, meaning a red-violet, as compared to a "warm" red in the red-orange range. Or we might speak of a "warm" blue (blue-green) compared to a "cool" blue (blue-violet). So the "warmth" or "coolness" of a color depends on what color it is next to or compared with. The intensity (brightness) and the value (dark or light) also affect color perspective, but given equal intensity and value, the *warmer color will seem*

6

to advance toward you, the *cooler color to recede*. In many abstract or nonobjective paintings, this factor is extremely important in manipulating space.

Color perspective does not, of course, apply to black and white drawings, but it is unavoidable when drawing with any colored medium. Look at the cover of this book. Are the arrows pointing right or left?

They are pointing both ways, of course, but most people first see the arrows pointing right because they are warmer, more advancing color. The arrows pointing left are seen as background because they are a cooler color.

Aerial Perspective

This perspective is especially useful in expressing deep space—far distance. Aerial perspective is based on the observation that atmosphere, particularly air close to the earth, contains particles of dust and moisture that tend to obscure vision. This effect is obvious in smog or fog but is also easy to see on a clear day. With distance, *clarity of detail* diminishes, *color intensity* diminishes, and *value contrast* diminishes. Things seem to become fuzzy and gray toward the horizon.

FIGURE 1–3

Linear Perspective

Probably the most easily recognized and best known means of expressing distance is linear perspective. It is based on the observation that the appearance of *size* diminishes with distance. It is called *linear* because one of the easiest ways to measure or judge diminishing size is by observing the diminishing distance between receding parallel lines. This book will be concerned with the basic principles of linear perspective.

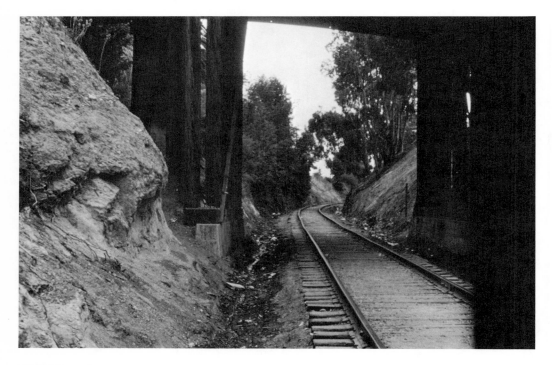

FIGURE 1–4

1. Perspective drawing enables us to represent three dimensions on a two-dimensional surface. (True or False)
2. Correct perspective is always necessary in good drawing. (True or False)

Match each type of perspective with its key idea.

3. Overlapping
4. Modeling or shading
5. Color perspective
6. Aerial perspective
7. Linear perspective

A. warm colors advance
B. decreasing size
C. gradual dark to light
D. one shape in front of another
E. decreasing contrast

Answers: 1. True; 2. False; 3. D; 4. C; 5. A; 6. E; 7. B.

9

2

tools, terms, and their uses

Aside from pencil and paper, tools used for perspective drawing serve two general purposes: to save time and to achieve a greater degree of precision. The degree of precision required for a finished drawing depends on its purpose. This varies widely. Quite precise and mechanical means are often necessary for such things as architectural drawing, interior design, product design, and advertising. After a building has been constructed or a product manufactured, photography is often used to show it, but in the design phase, accurate drawing is essential. Accurate use of tools can substitute for time-consuming measurement or computation, or tools may be used to verify the accuracy of freehand drawing.

This book requires very simple tools and materials. They are listed here with some suggestions for their use and some terms associated with them. As your skills and perception increase, you can discard mechanical aids for freehand drawing, or you can acquire more sophisticated tools for precision work, but exactness is important in the beginning to help you better understand the principles. Later, if you use tools only rarely, they can easily be improvised: a sheet from your pad of paper will serve as a straightedge, and its corner will serve in place of a triangle. If you are working on paper with irregular edges, you can always get a straightedge by folding any scrap of paper on a flat surface and then folding it a second time so that the edges meet exactly, making a square corner. To divide a line, folding a thin piece of paper will give you equal segments. A word of warning: If paper tools are used more than occasionally they are apt to become limp or ragged and serve no purpose of exactness.

PENCIL

Your pencil is your line maker. Pencils are available in a variety of styles from the simple No. 2 writing pencil to automatic drafting pencils that take leads of several thicknesses and provide a choice of hardness. HB is a good hardness, and a mechanical pencil using a .5 mm lead thickness is a good choice. If you are not using a mechanical pencil you will need a portable pencil *sharpener*. In any case you will need an *eraser*, and an *erasing shield* may be a help. This is a thin piece of metal about 2-½ × 3 in. with some holes in it. A hole is placed over the segment of line you want to erase, giving more precision than a large eraser usually permits.

When using a pencil, for best results keep it sharp and hold it as close to vertical as is comfortable. When using it with a straightedge, hold it in a constant position related to the edge; avoid weaving back and forth during the course of a line. Try to keep a consistent pressure on the pencil for consistent line width and darkness.

RULER

The ruler has two main functions: as a straightedge and as a measuring tool. Its measurement uses are discussed in Chapter 4; here we will consider its several other uses. Whenever precision is important, use a ruler or other straightedge as a guide, but if you want to draw a straight line freehand, try this: Put two dots on your paper fairly far apart. Put your pencil on one dot and keep your eye on the other. Draw the pencil smoothly and not too slowly from the first to the second dot. Your line will be quite straight if you have remembered to *keep your eye on where you are going*, *not on where you have been*. Try this several more times. Check the line straightness with your ruler. Your ruler is a clear plastic grid 2 in. × 12 in. or 2 in. × 18 in. This means it can be used for drawing parallel lines. *Parallel lines* are lines that remain the same distance apart during their length. Try this: Put your ruler down anywhere on your paper. Hold it firmly as you draw a line along each length edge. Lift the ruler. You have drawn two parallel lines 2 in. apart. Now place the ruler with one of its long lines on one of the lines already drawn, and again draw lines along its length edges. Lift the ruler. Now you have four parallel lines.

TRIANGLE

We use the triangle to draw horizontal lines, vertical lines, parallel lines in any position, and perpendicular lines in any position. A triangle is a shape with three straight sides and three angles. Your triangle may be one of two styles: an 8 in. 45 degree or a 10 in. 30–60 degree. It is clear plastic, which helps you to place it accurately. Both triangles have a 90-degree angle as their largest angle. This is also called a *right angle* or *square corner*; it fits into the square corner of your paper, exactly matching both edges. The edge of your paper going from left to right is called a *horizontal*, and all lines parallel to it are also horizontal. The edge of your paper going from top to bottom is a *vertical*, and all lines parallel to it are also vertical. If you wish to draw a horizontal in the middle area of your paper, match one side of your right angle with the vertical edge of your paper and slide it down until the other side is in the desired position to act as a straightedge for your horizontal. In this way any number of parallel lines may be drawn at any distance apart if they are horizontals or verticals. If you have a line that is neither horizontal nor vertical, it is called *diagonal*. If you wish to draw a line parallel to it, use this method: Place the longest side of the triangle on the line you want to repeat. Now place your ruler snugly against one of the remaining sides. Hold the ruler firmly as you slide the triangle along the ruler edge until you reach the desired placement for

the parallel line. Draw it. A vertical and horizontal are considered *perpendicular* to each other, which means they are going in opposite directions with a 90-degree difference between them. Place the triangle on the paper so that its short sides are not parallel to the sides of the paper. Draw the short sides meeting at the square corner. You have now drawn perpendicular lines which are not horizontals or verticals.

PROTRACTOR

The protractor is used to measure an angle. It is a clear plastic half circle with degrees marked and numbered around the curved edge. The numbers go from 0 to 180 (90 × 2); 180 degrees or two square corners equal one straight line. You can see on your protractor that this is a half circle. A full *circle* is twice 180, or 360 degrees. A straight line through the center of a circle is called a *diameter*. Half a diameter is a *radius*. A radius may be described as the shortest distance between the center of a circle and its edge. The edge of a circle is called its *circumference*. Many *angles* are not parts or circles. The only requirement for an angle is that it must be two straight lines meeting at a common point. Draw several angles of various sizes; then measure them. To measure an angle, use the protractor.

Find the center of the straight side of the protractor. It should be the center of a line connecting the last degree mark on each end. It will be perpendicular to the 90-degree mark. Place this center over the point of the angle. Make sure the straight edge of the protractor is parallel to one side, or *leg*, of the angle.

Now read the number where the second side, or leg, of the angle crosses the degree markings. If your angle is smaller than 90 degrees, use the smaller number; if your angle is greater than 90 degrees, use the larger number.

COMPASS

This is a metal tool with two legs, one of which contains a pencil or a lead. Our principal use for it will be to draw circles. You may want to use a circle template instead, but the compass gives you more size options.

TEMPLATE

A template is a pattern for tracing shapes. Your template is a flat piece of plastic with holes in it. The holes are precisely cut shapes and sizes of images that may be traced onto your drawing. They are time savers and are widely used in drafting for many purposes including architecture, electrical, and plumbing plans. You may

choose to use a circle template instead of a compass. A circle seen in perspective forms an *ellipse*. An ellipse template will be very helpful. A further explanation of the ellipse and the ellipse template is given in chapter 8. Practice using your template by holding your pencil in a vertical position and tracing some of the shapes. To place the traced shape where you want it, start with two perpendicular lines on your paper. Find the centering lines on the edges of the circle or ellipse hole. Place these over the perpendicular lines on your paper.

In this chapter some terms have been introduced that may be unfamiliar. It is important that you understand and remember their meanings. Here is a list of these terms. Match them with definitions from the list on the right, as 1-A.

SELF-TEST *(answers are below)*

If some of your answers are incorrect, reread the text; then ask questions and discuss it until it becomes clear and easy to remember.

1. parallel		A.	always the same distance apart
2. horizontal		B.	90 degrees
3. vertical		C.	circle edge
4. perpendicular		D.	two straight lines meeting
5. angle		E.	left to right
6. triangle		F.	straight line across a circle through its center
7. right angle		G.	opposite directions
8. square corner		H.	top to bottom
9. diagonal		I.	straight line from center to outside of circle
10. protractor		J.	slanted line
11. diameter		K.	tool for drawing circles
12. radius		L.	tool for measuring angles
13. circumference		M.	circle in perspective
14. compass		N.	right angle
15. template		O.	pattern for drawing shapes
16. ellipse		P.	shape with three sides

1. A; 2. E; 3. H; 4. G; 5. D; 6. P; 7. B; 8. N; 9. J; 10. L; 11. F; 12. I; 13. C; 14. K; 15. O; 16. M.

3

linear
perspective

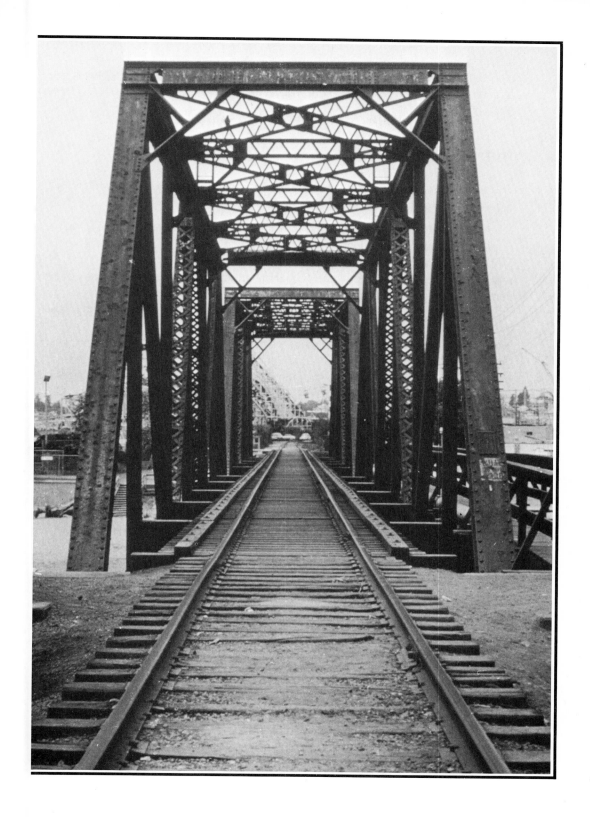

This chapter presents essential concepts for drawing in linear perspective and guides you through drawings in one-, two-, and three-point perspective. Do the self-tests as you come to them; answers are at the end of the chapter. If your answer does not agree with the answer given, review the material covered to find out why.

DIMINISHING SIZE

The key idea underlying linear perspective is *diminishing size. Distance makes a difference! The farther away an object is, the smaller it appears.*

Try this experiment: Put your hand in front of your face. How much of your view does it cover: an entire house, a wall, a table? Now move your hand back about a foot from your face. How much does it cover? You know your hand is not as big as a desk or a wall. Extend your arm fully. How much smaller your hand now seems compared to objects near you! Objects at close range appear much larger than they appear at a distance, and the farther away they are, the smaller they seem, until they disappear from view. To judge this ever-diminishing size, consider two parallel lines, always the same distance apart. The distance between them, which could be marked by rungs on a ladder or ties between railroad tracks, seems to diminish as it recedes into the distance until it disappears and finally vanishes at a vanishing point. The same might be true of a fence. We seldom see either of these examples, however; railroad tracks and fences have a way of turning corners or disappearing behind hills or buildings or trees. But, when they *do* continue *straight, flat,* and *unhidden,* those two parallel lines seem to converge, or meet, *at a vanishing point on the horizon line, which is your eye level.*

The following pages will explain these terms more fully.

EYE LEVEL

The eye level is the position where your eyes are located (physically) in relation to the subject viewed. If a level horizontal line were drawn through your eyes, where would it seem to be on your subject? This is the eye level.

Try this experiment: Sitting down, hold a pencil in front of your eyes and look around the room. Keep it parallel to the floor. This is where your eye level is in the room as long as you remain seated. Now stand up. See how your eye level has changed?

The photos in figures 3–1, 3–2, and 3–3 show a table at three different eye levels. Notice how the shape seems to change. Lying on the floor might give you this view because your eyes are below the top of the table (fig. 3–1).

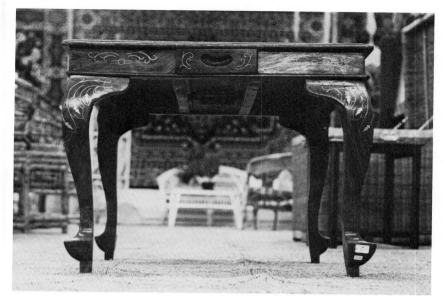

FIGURE 3—1

If you sit up, your eyes are on a higher level—above the top— and you might see this view (fig. 3—2).

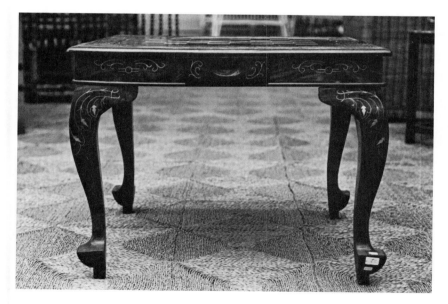

FIGURE 3—2

19

If you sit on a chair, your eyes are even higher, and you might see this view (fig. 3–3).

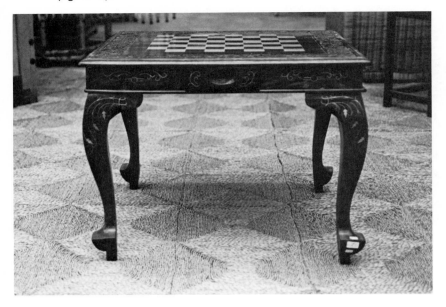

FIGURE 3–3

If you look up or down without moving your head, your eye level is unchanged. It is only when the location of your eyes changes in distance from the floor that your eye level changes. When you are looking at a photo or a drawing, you are seeing the subject from the eye level of the camera or the artist.

Look at this shelf. Is the camera's eye above it or below it? Can you see the underneath side? If you can, the eye level is below it.

FIGURE 3–4

HORIZON LINE

The horizon is the place where the earth and sky seem to meet. The horizon line is always a straight level line and is most easily seen on flat land where there are no mountains, buildings, or trees in the way, or where a large body of calm water and the sky seem to meet. It should not be confused with the irregular profile of mountains, buildings, or trees seen against the sky. Remember that the horizon line is where *level* land or water would be seen against the sky. In figure 3–5, where is the horizon line? (The answer is given at the end of the chapter).

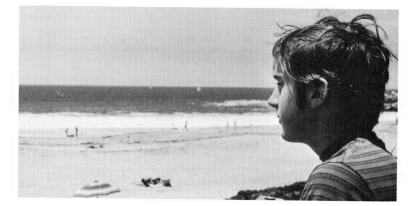

FIGURE 3—5

The horizon line is the same as your eye level because the height of your eye level determines where you will see the horizon. If you are close to level land or water, you will see very little of the earth compared to the amount of sky you can see. This is called a *low eye level* (fig. 3–6).

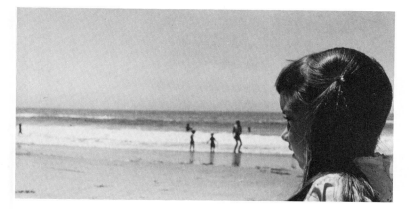

FIGURE 3—6

If you are high above level land or water, you can see much more of the earth compared to the amount of sky you can see. This is called a *high eye level* (fig. 3–7). But no matter where you are, your eye level is always on the horizon line; they are one and the same.

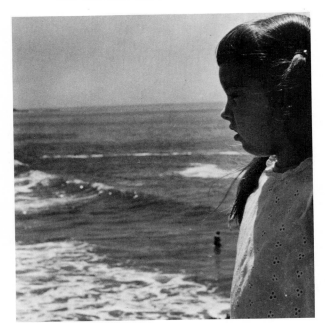

FIGURE 3—7

On each of the following photos (figs. 3–8 and 3–9) draw the eye level (horizon line) and label it high or low eye level. (Answers are given at the end of the chapter.)

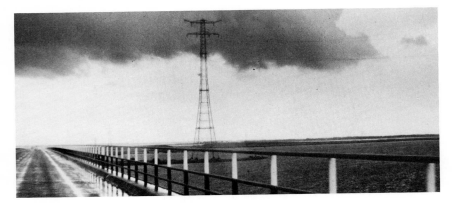

FIGURE 3—8

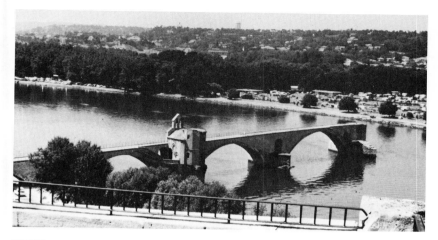

FIGURE 3—9

Remember:

FIGURE 3—10 LOW EYE LEVEL.
You are on ground level.
Ground compressed.

FIGURE 3—11 HIGH EYE LEVEL.
You are high above ground level.
Ground expanded.

PICTURE PLANE

The picture plane is the surface of which you draw; it is also an imaginary vertical surface, like a window, through which you look at your subject. In this way, you translate your three-dimensional view of the world to your two-dimensional surface. Sit in front of a window, holding your head very still. Trace directly on the glass with a grease pencil the outlines of the objects you see on the other side.

When you have finished, place a piece of white paper in back of the glass, and you will see a perspective drawing.

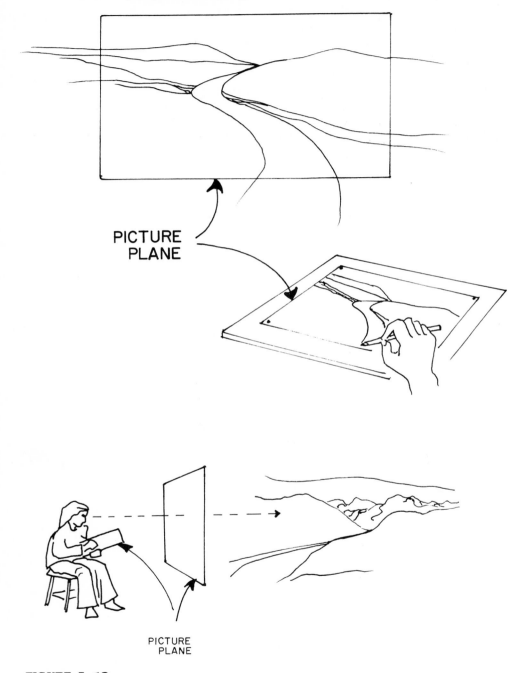

PICTURE PLANE

PICTURE
PLANE

FIGURE 3—12

24

VANISHING POINT

A vanishing point is the place where a diminishing size disappears on the horizon line. Since a diminishing size can be measured by receding parallel lines, as in the railroad tracks, it follows that *all lines parallel to each other and receding from the picture plane go to the same vanishing point.*

The next three photos are in one-point perspective. In each there is one centrally located vanishing point. This vanishing point is also called the center of vision (CV) because it is directly in front of the place where you are standing, called the station point (SP). In these photos trace all the receding lines to the horizon line (eye level EL). Any lines parallel to each other will go to the same vanishing point. Label horizon line (HL) and vanishing point (VP). (Answers are given at the end of the chapter.)

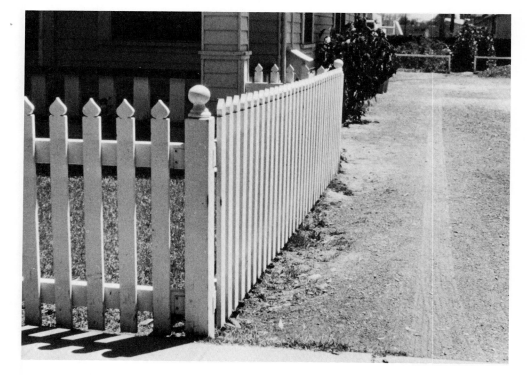

FIGURE 3–13

25

FIGURE 3—14

FIGURE 3—15

26

ONE-, TWO-, AND THREE-POINT PERSPECTIVE

Perhaps you have heard of one-point perspective, two-point perspective, and three-point perspective. These perspectives simply mean different ways of viewing a three dimensional object. If only one of the three dimensions (the depth) is receding from the picture plane, there will be only one vanishing point, and we have one-point (1 pt) perspective. If two dimensions are receding (depth and width), there will be two vanishing points, one for each dimension, and we have two-point (2 pt) perspective. If all three dimensions are receding (depth, width, and height), there will be three vanishing points, one for each dimension, and we will have three-point (3 pt) perspective.

One-Point Perspective

In one-point perspective, only the depth is receding from the picture plane. Consider this box; it opposite surfaces are parallel to each other and so are the edges of those surfaces.

FIGURE 3—16

From this view the height is parallel to the picture plane (that is, the edge of the paper); therefore the height is not receding and that dimension will not have a vanishing point. On this box there are four height edges—although we see only two. Here the width is parallel to the picture plane; it is likewise not receding, and therefore the width dimension will not have a vanishing point either. There are four width edges on this box. Here we see three.

In this case there will be a 90-degree angle or square corner-between the height and width edges. This may be called a *right angle* or *perpendicular*.

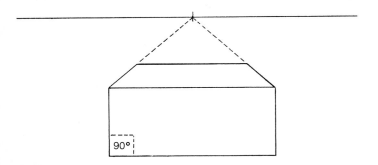

FIGURE 3—17

If your eye level is above the top of the box, you can see the top. Here the depth dimension is *not* parallel to the picture plane. This top surface is going back in space, receding from the picture plane. If this depth continued instead of stopping at the back edge of the box, it would eventually disappear at a vanishing point on the eye level. This vanishing point is directly in front of where you are standing. It is the center of vision (CV).

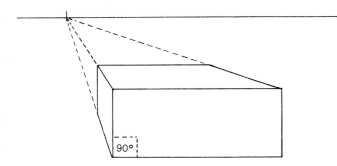

FIGURE 3—18

28

If you were not standing directly in front of the box as in figure 3–18, you might see some of its side depth dimension as well as the top. It could still be in one-point perspective if there is a 90-degree angle (a right angle) forming a square corner between the height and width, both of which are parallel to the picture plane (the edges of your paper).

You are seeing this box, then, in one-point perspective because only one of its three dimensions is receding from the picture plane.

Here is a photo of a box in one point (fig. 3–19). Draw it. Include the eye level and vanishing point and label them.

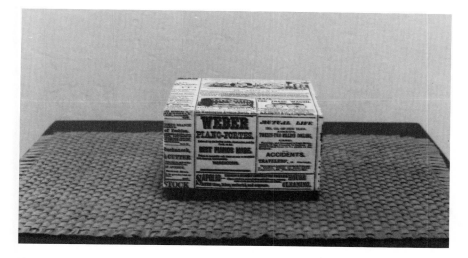

FIGURE 3–19

1. Start by drawing the face of the box closest to you.
2. Then draw the eye level and vanishing point. Label them EL and VP.
3. Draw the receding depth from each corner of the face toward the VP.
4. Limit the top depth with a horizontal.
5. When one depth line is drawn the rest are determined. Complete the back of the box with horizontals and verticals.

See chapter 2 for ways to draw parallel lines with the triangle and the ruler.

Sometimes the receding side of a box can be seen only as an edge. Here is a photo of another box in one-point perspective (fig. 3–20). You cannot see the receding top, only the edge of it, because the top is exactly on the eye level; nor can you see the receding side on the left. Only its edge is visible, because that side crosses the vanishing point directly in front of you. It is useful to remember: *A receding plane (or surface) is seen as an edge (or straight line) only when it is on the eye level or when it or its extension crosses the vanishing point (fig. 3–21).*

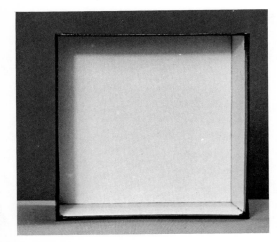

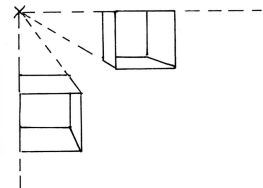

FIGURE 3—20 **FIGURE 3—21**

Here is a group of boxes in one-point perspective. You need not copy this photo; instead, use it as a basis for your drawing. Use one vanishing point for all the boxes, showing them to be arranged parallel to each other. Show some below eye level and some above, some to the left of the VP and some to the right. Start with EL and VP. Next plan the placement of the boxes.

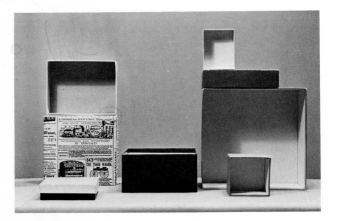

FIGURE 3—22

30

Placement

Some people prefer to work from front to back, others from back to front, still others start with the largest form and arrange others around it. Any of these methods will work well and will help you to avoid equivocal space.

Equivocal Space

When several objects are grouped on a single flat surface, it is important to clearly show the space each occupies. If two objects in a drawing occupy the same space, it is called equivocal space; this means saying two things at the same time. Our minds won't permit us to accept an impossibility, so we often see one of the objects as floating. Avoid this problem by lightly drawing all hidden lines, particularly those describing the area each object covers. Remember, objects placed farthest from the eye level are nearest to the viewer.

Remember, *all lines (or edges) parallel to each other and receding from the picture plane go to the same vanishing point.*

For more practice with one-point perspective, draw a page of boxes some of them open.

Two-Point Perspective

FIGURE 3—23

Figure 3-23 is another view of a box. The height is parallel to the picture plane (not receding), so it will have no vanishing point. The depth, however, is not parallel to the picture plane. It is receding toward a vanishing point on the eye level. Neither is the width parallel to the picture plane; it is receding toward its vanishing point on the *same* eye level.

You are seeing this box in two-point perspective because two of its three dimensions are receding from the picture plane.

Each of these dimensions has its own vanishing point, but both points are on the same eye level since there can be only one eye level for any single view.

Draw the box in two-point perspective.

1. Start with the leading edge (the edge closest to you). It is a vertical *height* edge of the box. Add the eye level and vanishing points, keeping them far apart.
2. Next, the *width*, the front left side, top and bottom edges receding toward the left vanishing point and ending at the left height edge.
3. Now draw the depth, the front right side, top and bottom edges receding toward the right vanishing point and ending at the right height edge.
4. Now show the back *depth* edge. It goes from the *left* height edge to the *right* vanishing point.
5. Finally, add the back *width* edge—from the *right* height edge to the *left* vanishing point.

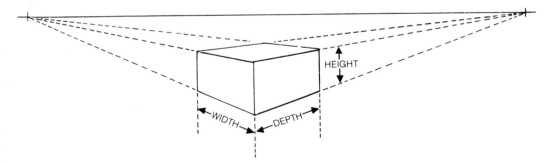

FIGURE 3—24

Some of the edges of this box (fig. 3—24) are hidden, but if it were glass, you would see all four edges for each dimension. All four *width* edges recede to the *left* vanishing point and all four *depth* edges recede to the *right* vanishing point, because *all lines parallel to each other and receding from the picture plane go to the same vanishing point.*

Here is the same group of boxes you drew in one-point perspective, but now you are seeing them in two-point perspective. Draw from the photo using two vanishing points placed far apart. Lightly draw all hidden edges.

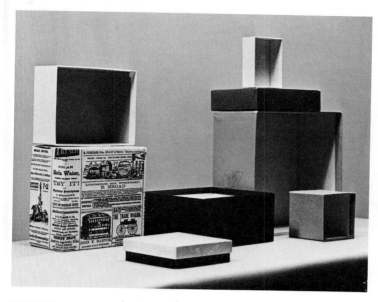

FIGURE 3—25

Draw the eye level on each of the following two photos. Label each *1 pt* or *2 pt.* Answers are at the end of the chapter. For more practice with two-point perspective, draw a page of boxes, some of them open. Show dotted lines for all hidden edges.

FIGURE 3—26

FIGURE 3—27

Three-Point Perspective

What happens if the box is tilted? The depth is receding to its vanishing point. The width is receding to its vanishing point.

FIGURE 3—28

34

But now the height is also receding to a third vanishing point. *When the height dimension recedes, its vanishing point will be either directly above or directly below the eye level vanishing point* that would otherwise govern it—how far above or below depends on the steepness and direction of the slant. This is why three-point perspective is called *the perspective of the slanted plane*.

You are now seeing this box in three-point perspective because all three of its dimensions are receding from the picture plane.

Three-point perspective, or the perspective of the slanted plane, applies to any receding slanted plane, that is, where a height dimension is involved, such as roofs, streets, roads, ramps, and stairways.

Draw this tilted box.

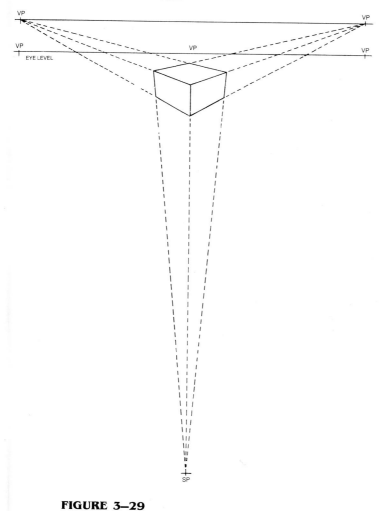

FIGURE 3–29

1. Start with the corner closest to you—the top front corner.
2. Extend the height line down to a vanishing point below it. All height edges will go to this vanishing point.
3. Locate width and depth vanishing points on a horizontal above the box. All depth edges go to the vanishing point on the right; all width edges go to the vanishing point on the left. The box is complete.
4. Draw the table under the box. It is in one-point perspective with its VP on eye level.

You will notice that when the box is tilted, all three of its dimensions recede from the picture plane; one corner is closer than any of the others. Therefore, the top and bottom surfaces are slanted planes, as are the width and depth surfaces. For this reason the width and depth vanishing points are on a horizontal above the eye level used for the level table underneath. All three vanishing points for the box are now considered to be three-point vanishing points because all planes of this box are slanted.

Sometimes only one plane (or surface) of a form is slanted, for example, when a building is seen in two-point perspective and has a slanted roof. In this instance, only the roof would be in three-point perspective, and its vanishing point would be vertically above or below the eye level vanishing point used for the rest of the building. This case is explained in greater detail in chapter 6.

When the face of the camera lens is tilted up or down instead of being vertical, the resulting photo is in three-point perspective. This is because the front of the camera is the picture plane. This is likely to happen when photographing a tall building from a fairly close distance, as in Figure 3–30.

Locate the vanishing point for each slanted plane shown in (fig. 3–30). Answers are at the end of the chapter.

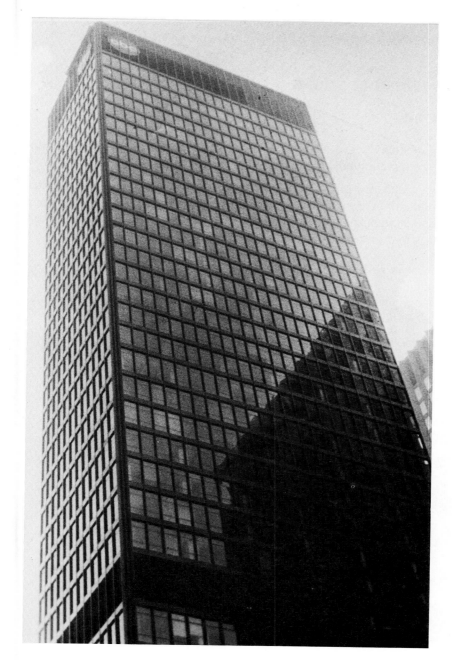

FIGURE 3–30

You have now drawn in one-point, two-point, and three-point perspective. Your further studies of perspective will be built on this knowledge.

SOME GENERAL CONSIDERATIONS

Using Mechanical Aids

Accurate use of tools can substitute for time-consuming measurement or computation, or may be used to verify the accuracy of freehand drawing.

In freehand drawing, the objective is a convincing approximation of the appearance of things rather than the precise accuracy obtained with drafting tools; however, when straight lines are needed, don't hesitate to use a ruler. If you want to develop skill in drawing freehand straight lines, see chapter 2.

Perspective as a Means of Expression

In drawing and painting, the use of perspective enables a convincing representation of the real world, and it operates as an effective means of expression as well.

One-point perspective conveys a feeling of formality and stability. This quality of frontal confrontation can command respect or awe (fig. 3–31).

FIGURE 3–31

Two-point perspective is more dynamic, more active, more exciting. Its angular lines are more apt to gain the attention of the viewer. For this reason, two-point perspective is used more than one-point perspective in modern advertising and illustration (fig. 3–32).

FIGURE 3–32

Three-point perspective can be even more dynamic and is often used to emphasize or exaggerate size or distance (fig. 3–33).

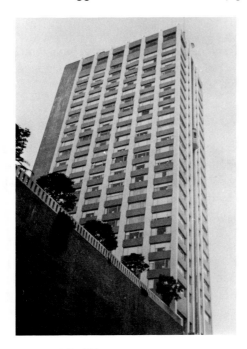

FIGURE 3–33

It is possible to carry any of these to an extreme that defeats the purpose of believable representation.

Avoiding Unwanted Distortion

In One-Point Perspective, place the vanishing point well within the central area of the drawing.

In Two-Point Perspective, place the vanishing points far apart, with at least one of them outside the drawing.

In Three-Point Perspective, keep the drawing with the triangle formed by the three vanishing points.

Remember, you cannot draw an object beyond the vanishing point because it will have vanished from your view.

Diminishing Perspective Effect

In general, the perspective effect of linear perspective diminishes with distance. In other words, linear perspective is more obvious in objects close to you than in those same objects viewed at a distance.

OTHER TRADITIONS

Linear perspective is only one of many effective ways of expressing images in space. Different purposes, cultural traditions, and means of expression produce a variety of ways of expressing depth, and of using space to express concepts other than distance as we visually perceive it.

Isometric Drawing

Isometric drawing is a tradition in our own culture used for drafting purposes. It shows depth by means of specific angles; size does not diminish with distance. In this way a craftsman may take flat measurements from any part of the drawing and use them on the three-dimensional form being constructed.

Oriental Space

There is a similarity between isometric drawing and one oriental tradition used to express form. In both cases size does not diminish with distance, but there is an apparent difference in purpose. In oriental art, concern for pattern, detail, and negative space can be of greater importance than optical realism.

Size Exaggeration

In our own tradition before the Renaissance we see size exaggeration of forms to indicate importance or emphasis. This continues today in advertising, in comic strips, and sometimes in the creative work of children or naive adults.

Simultaneous Views

Early in this century Cubism showed us a new view of our world. One of the ways of doing this was the simultaneous use of two views of the same object or figure. A simple example might be a drinking glass or mug shown with its open top expressed as a round circle and its base expressed as a horizontal line. If you take this representation literally in an optical sense, it would seem to be a curved tube. However, if you think of it in terms of its function, it takes on a deeper reality: As you drink from a glass, it looks round and feels round; when you set it down on a table, its bottom is flat, and a horizontal line is a symbol for flatness. Here symbols are used differently than is usual for optical realism. It is true that both top and bottom can be seen in the way expressed, but not at the same time; so here we have two views simultaneously shown.

Enhancing Realism as Expression

The two-dimensional expression of optical realism, whether drawing, painting, print making, or photography, is often enhanced to make the illusion or the message more convincing. This may be done with selection, exaggeration and or distortion.

Selection is an unavoidable factor, and is always an expressive element. Often that which is not included is just as important to the message as that which is included. Having selected the subject in the first place shows interest or intent.

Exaggeration or distortion may be a factor of selection, or may be contrived by arrangement, proportions, or variations of clarity or contrast in value, form, shape, color, or context. Personal technique or process is influential here as well.

Optical Realism

Optical realism is not the only truth to be expressed, but it is one important truth. To the extent that a work has the clear intent of representing our optical experience, it relies on the concepts of perspective.

FIGURE 3—34 Answer to self-test, Figure 3—5

FIGURE 3—35 Answer to self-test, Figure 3—8

Low eye level. You are on the road. This is flat land; therefore, the eye level (horizon line) is where earth and sky meet. You see more sky than earth.

FIGURE 3—36 Answer to self-test, Figure 3—9

High eye level. You are on a high bank above the river and can see the tops of trees on both sides of the river; so your eye level (horizon line) is above them. However, beyond the trees the land rises in a gentle hill just a little higher than where you are standing; therefore your eye level (horizon line) is a little below the top of the hill. You see more earth than sky.

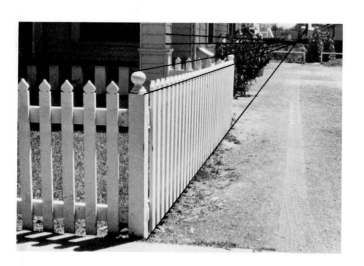

FIGURE 3—37 Answer to self-test, Figure 3—13

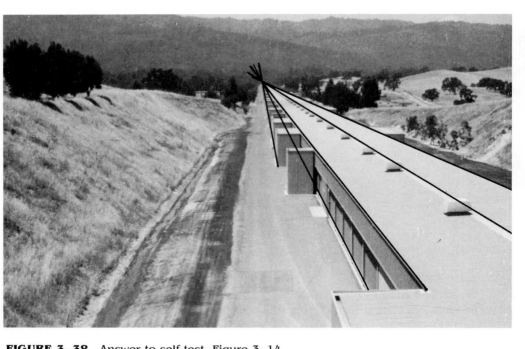

FIGURE 3—38 Answer to self-test, Figure 3—14

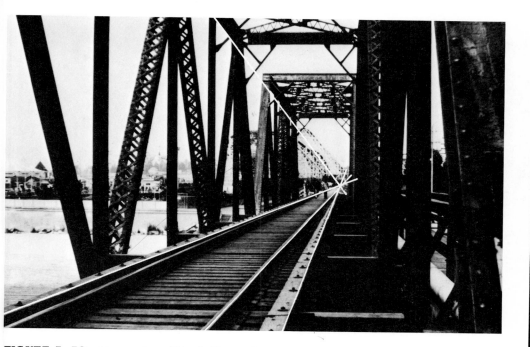

FIGURE 3—39 Answer to self-test, Figure 3—15

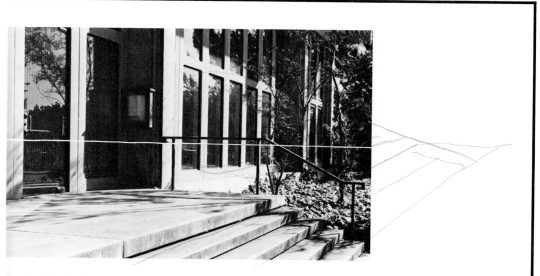

FIGURE 3—40 Answer to self-test, Figure 3—26. Two-point perspective.

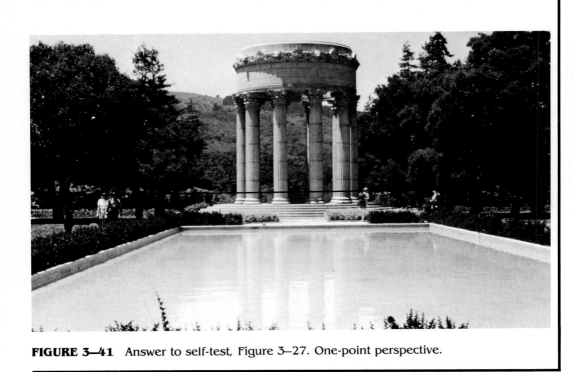

FIGURE 3—41 Answer to self-test, Figure 3—27. One-point perspective.

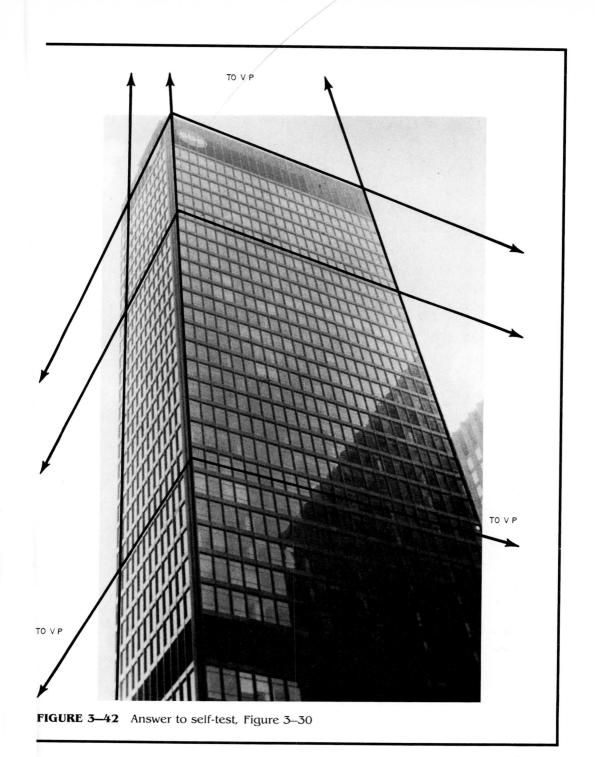

TO V P

TO V P

TO V P

TO V P

FIGURE 3—42 Answer to self-test, Figure 3—30

dividing
and multiplying
space

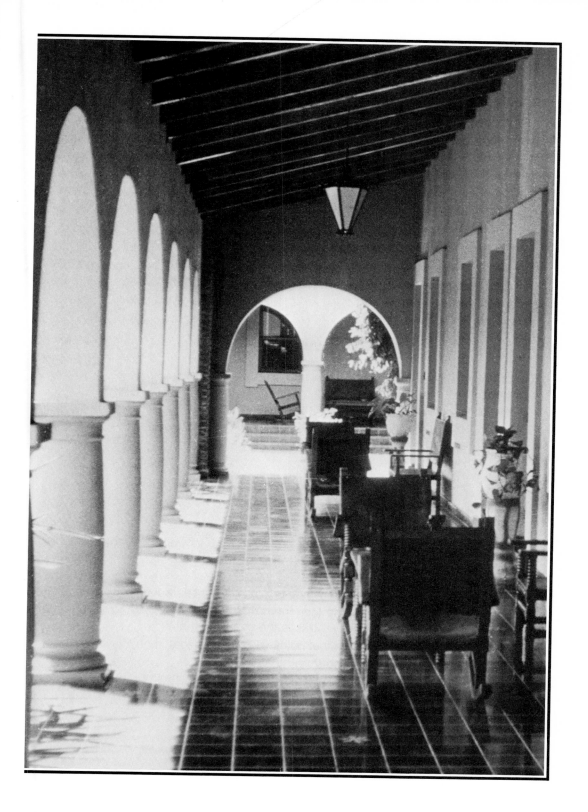

MEASUREMENT

In dividing and multiplying space we are working with a known measurement; we are dividing it, repeating it, or transferring it. Measurements must be taken from nonreceding lines. *Any line which is not receding is parallel to the picture plane and may be accurately measured to establish a size or proportion.* These may be vertical, horizontal, or slanted. To establish which are not receding, the intent of the drawing must be considered. Most veritcal and horizontal lines represent non-receding dimensions. Exceptions are a receding horizontal coinciding with the eye level or a receding vertical coinciding with a one-point vanishing point. These are shown in figure 3–21. Slanted lines, sometimes called oblique or diagonal, often represent receding horizontal edges. Since there are times when they do not and therefore may be measured, remember to consider the drawing intent.

This chapter discusses several ways to divide or multiply receding space after a depth has been established by eye or calculation. Chapter 5 shows how to calculate depth precisely.

DIVIDING AND MULTIPLYING SPACE

Using Diagonals for Dividing or Multiplying

Dividing or multiplying nonreceding space can, of course, be done by measurement and calculation, but the diagonal method may be used as a time saver. Diagonals drawn to opposite corners divide a square or rectangle in half by locating the center point where a vertical or horizontal may be drawn, dividing the shape in half. This works whether or not the shape is receding.

Using Diagonals for Dividing in Half

Trunk Suppose a box in two point is a trunk and you need to find the center of its receding side to place the latch. Use diagonals:

1. First, draw the trunk as a closed box in two-point perspective below eye level.
2. To find the center of the long side, draw diagonals to its opposite corners. The point at which they cross is the center of that side.
3. Draw a vertical through that point. Next draw the latch on this vertical where the lid overlaps the front of the trunk.
4. Now suppose a handle is centered on the end of the trunk. Again, diagonals drawn to opposite corners will determine the center.

5. Draw the handle.

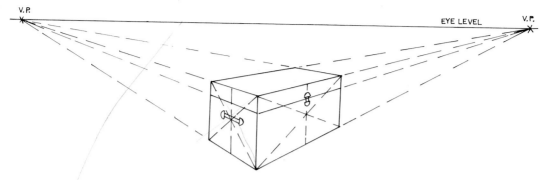

FIGURE 4—1

6. Now suppose the trunk has two straps. To locate them, divide each half of the front into half again by drawing diagonals, then draw verticals from the center points. These are the strap centers.
7. The straps will also go across the lid to the vanishing point used for the top. The trunk is complete.

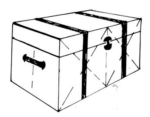

FIGURE 4—2

Using Diagonals with a Measuring Point for Multiplying

Diagonals may also be used to multiply a receding dimension.

Fence Suppose you want to draw a fence receding into the distance. Diagonals used with a measuring point can help you to multiply the sections of fence if all the

51

posts are in fact the same height, the same distance apart, and on a level surface. See figure 4–3.

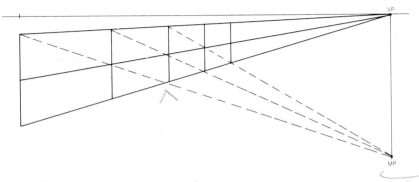

FIGURE 4–3

1. Start with the eye level and a vanishing point (VP), then draw the first post well below eye level.
2. Now draw a line from the top of this post to the VP. The top of each post will be on this line.
3. Draw a line from the bottom of the first post to the VP. This is the ground line. The bottom of each post will be on this line.
4. Find the center of the first post by measuring it, and draw a line from this center point to the VP. The center of each post will be on this line.
5. Next, draw the second post at whatever distance looks right. This establishes the distance between all the posts.
6. Now draw a diagonal from the top of the first post through the center of the second post and continue it to the ground line. This locates the base of the third post.
7. Continue this diagonal to meet a vertical from your vanishing point at point *M*. Point *M* acts as a *measuring point*. All diagonals will meet at this point.
8. Draw the second diagonal from the top of the second post through the middle of the third to the base of the fourth. This diagonal if continued goes to the measuring point. Using the *M* point prevents a small error at the beginning from multiplying into a large error as the distance progresses.
9. Continue as far as you like.

A measuring point for a horizontal plane is *on* a horizontal plane, the eye level. A measuring point for a vertical plane is *on* a vertical plane, above or below a vanishing point. *Equally spaced divisions receding in unlimited space can be found with diagonals.*

Sidewalk, one point This method is also used for horizontal surfaces, as when drawing a sidewalk. In many amateur drawings, sidewalks look as if they are standing on end or on edge. Follow this procedure to make a sidewalk appear flat. See figure 4–4.

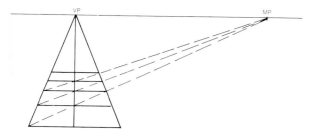

FIGURE 4–4

1. Draw the eye level, (EL) and vanishing point. Make this one-point perspective.
2. Next, draw two lines representing the two edges of the sidewalk going back to the VP.
3. Draw another line exactly between them to the VP.
4. Now, draw the first horizontal, crossing all three lines at the bottom.
5. Add the second horizontal as far back as you think it should be.
6. The next step is similar to a fence lying flat on the ground. A diagonal from one end of the first through the middle of the second line shows where the third should be placed.
7. Continue this diagonal to the eye level, establishing point *M*. Again, point *M* acts as a measuring point. All diagonals will meet at this point. Remember that when a measuring point is used to divide a horizontal plane, it is *on* a horizontal plane: the eye level. When it is used to divide a vertical plane, it is *on* a vertical plane—above or below the VP.

Sidewalk, two point In two-point perspective the procedure is the same except that cross divisions go to the second vanishing point, and point *M* is on the EL between the VPs. The only time it is exactly halfway between them is when the two sidewalk sections intersect at a right angle vertically below the midpoint.

To draw the sidewalk in two point;

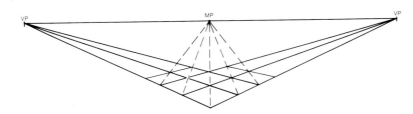

FIGURE 4—5

1. Start with EL and VPs.
2. From each VP draw the two outside lines for the sidewalk.
3. Overlap them where they meet giving them one square or rectangle in common.
4. Locate the center of it with cross diagonals and extend one to the EL to establish an M point.
5. Draw a line from each VP through the center of the square and beyond. You now have two divided sidewalks.
6. Proceed as before using the measuring point and diagonals. Continue as far as you wish.

It is, of course, quite possible to use the diagonal method of multiplying receding space without using a measuring point; however, don't plan to make more than one or two extensions without it. Beyond this, it is difficult to avoid error without the *M* point, as any small error is multiplied with each extension.

By increasing the number of rows, this method will yield a repeated pattern or equal spacing for a series of forms, horizontally or vertically, for walls, ceilings, or floors. But remember, these are likely to be repeated rectangles rather than squares since the depth judgment was made by eye rather than by measurement. In chapter 5 we will measure receding depth.

Using a Measuring Line

A measuring line is a line on which measurements have been made for transfer to another direction. This transfer may be made either to a receding or nonreceding line or surface. It may be used to transfer proportions while reducing or expanding

size, or it may be used in changing perspectives. It always is a time saver because it eliminates the need for awkward calculations. Sometimes a ruler is used as a measuring line, as in figure 4–6.

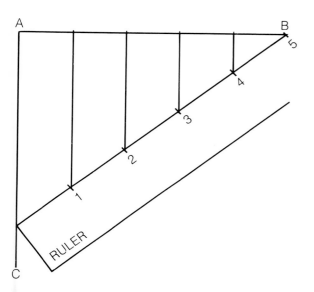

FIGURE 4—6

Dividing a Nonreceding Line

To divide the line *AB* into five equal segments,

1. Draw a line perpendicular to *AB* through *A* to *C*.
2. On your ruler, choose a convenient length greater than *AB* and easily divisible by 5; here, 5 in.
3. Place the 5-in. mark on point *B* and then swing the ruler down until its end touches line *AC*.
4. Mark each inch. From these marks, draw lines parallel to *AC* intersecting *AB*.
5. These intersections divide *AB* into five equal segments.

This method may be used for any number of equal segments, and any convenient marking on the ruler may be used, fractions or multiples of an inch. The total used length of the ruler must be longer than the line to be divided.

Projection

Suppose you have limited receding space and an uneven number of divisions or irregular spacing on a receding surface. If so, use a measuring line for projection (fig. 4-7):

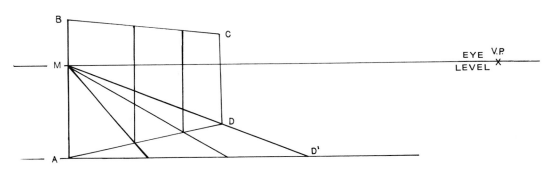

FIGURE 4—7

Odd-Numbered Divisions

1. Draw a receding wall and label the corners *A*, *B*, *C*, and *D*.
2. Show the eye level and vanishing point.
3. Draw a horizontal through *A*.
4. Point *M* is where *AB* crosses the eye level. Draw the diagonal *MD* and extend it to cross the horizontal at D^1.
5. The line AD^1 is a nonreceding view of the line *AD*, so it can be divided by measurement into any uneven number, or it can be used to locate irregularly spaced doors and windows.
6. Divide the line AD^1 into three equal segments. Use a measuring line.
7. Now draw a line from each of these division points to *M*. Where these lines cross *AD*, draw verticals. The plane *ABCD* is now divided into three equal parts.

Irregular Spacings Now try the projection method for some irregular spacings on the wall (fig. 4–8).

In figure 4–8 the measuring line AD^1 has irregularly spaced divisions representing a window and a door projected from a nonreceding view of a wall. In architectural drawing this view of a wall is called an *elevation*. Since it is not receding, exact proportions (height and width measurements) may be taken from it and transferred to a perspective drawing, as in figure 4–8. The measuring line places the width divisions, but to keep the proportions accurate, make sure the height measurement *AB* in the elevation is repeated exactly as *AB* in the perspective view. All other height measurements for windows, doors, ornaments, and the like are also made on this line then taken toward the VP to intersect vertical placement lines.

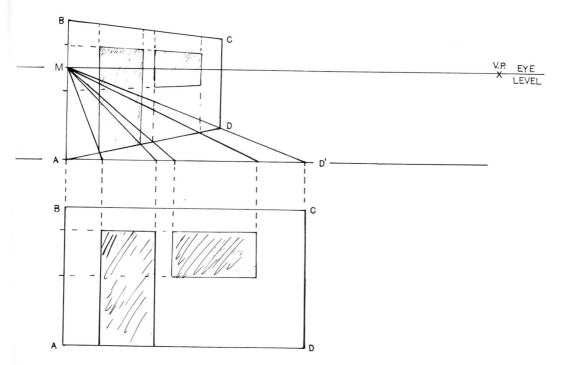

FIGURE 4—8

This is the procedure:

1. Draw a nonreceding view of a wall *ABCD* with a door and window.
2. Conveniently above it, draw a horizontal.
3. Vertically above *AB* on the horizontal, draw the vertical *AB* the same height as *AB* below.
4. Draw the eye level and VP for the perspective view.
5. Locate D^1 on the horizontal vertically above *C*.
6. Locate the door and window on AD^1.
7. Draw the diagonal MD^1.
8. Draw the lower edge of the receding wall from *A* to the VP crossing MD^1 and locating the corner *D*.
9. A line from *B* to the VP forms the top of the wall, establishing point *C*.
10. *ABCD* above the line is now the receding view of *ABCD* below the line.
11. Connect the door and window division points on AD^1 to *M*.
12. Draw verticals where they intersect *AD*. The door and window are now located vertically.
13. Their height placements are found by transferring height measurements from the lower *AB* to the upper *AB* and going from these points toward the VP to intersect corresponding verticals.

Store Front

Figure 4–9 is a photo of a store front taken in one-point perspective. Draw it as an elevation then project it to two-point perspective.

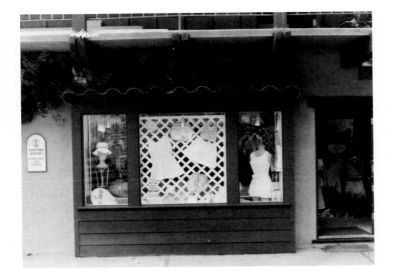

FIGURE 4–9

Compare figure 4–9 with figure 4–10 to see how one-point perspective differs from an elevation. To draw this store front as an elevation, eliminate all receding planes: Draw the bay with the same bottom line as the wall. Show overhead beams as holes in the wall with the walkway thickness above them. Here the tile roof is slanted, so it would be shown as back and front edges only. The interior of the store beyond the door would not be shown.

To draw the perspective projection, you will need a VP beyond the *M* point to draw the bay, overhang, and beams. Take all divisions to the wall of the building; then project forward from the VP for the bay, beams, and overhang. The door may be partly hidden by the bay. Draw the tile roof as flat or see Chapter 6, the Slanted Plane.

Here is an example of an architectural drawing in perspective using the projection method.

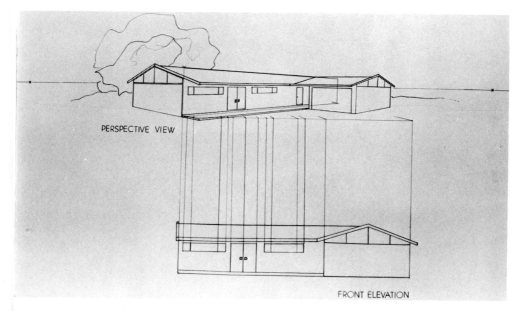

PERSPECTIVE VIEW

FRONT ELEVATION

FIGURE 4–10

5

proportioning and scale drawing

In freehand drawing, general proportioning is done by eye or estimate, but because some drawing purposes require exact proportioning, precise measurement of depth dimensions, or scale drawing, you will need some experience with all these. Proportion is a comparison. It relates one dimension or quantity to another, and is often expressed as a fraction, such as "this is a third of that length." The term "pleasing proportions" usually refers to a harmony of dimensions within a single form or a group.

ESTIMATING PROPORTIONS

In estimating proportions, try to compare measurements of opposite directions, such as a height measurement compared to a width measurement. Often this is done just by looking, though there are several commonly used aids. One is the practice of closing one eye and holding a pencil at arm's length with a stiff elbow. A measurement on the object being drawn is matched by the distance between the end of the pencil and the artist's thumbnail. It is then compared with other dimensions on the subject. Another aid is a finder or framer held to the eye. It consists of a square hole in cardboard or stiff paper so that vertical and horizontal measurements may easily be compared. A clear grid ruler 2 in. wide is even better for this use. If a hole is punched in the center of one end and is strung with a thread loop or paper clip, it acts as a pendulum, giving vertical and horizontal references as well as proportions.

JUDGING PROPORTIONS

A properly proportioned drawing is one in which all objects are in proper size relationship to each other, no matter where they are placed in space. For instance, in drawing the interior of a room, you would want the furniture to be a reasonable size in relation to the height of walls and doors, so that adults in the room could use it comfortably. Similarly, people in a room should not appear to be giants or dolls.

SIZE CHANGES WITH PROPORTIONS UNCHANGED

Although exact proportions are a direct result of measurement, they may be reduced or expanded in size without measurement and calculation.

Measuring Line:

This was happening in figure 4–6 using the measuring line: the distance between inch marks was reduced, but remained equal. Reversing the direction would enable enlargement.

The measuring line, of course, may instead be divided by irregular spacings, producing a reduced or expanded size without changing the proportions of the irregular spacings.

Diagonal:

Another convenient means of reducing or expanding size while retaining proportions is by using a diagonal. *Any square or rectangle may be reduced or enlarged by drawing a diagonal from corner to opposite corner.* At any point along this diagonal, draw a horizontal and a vertical to the edges. The resulting shape will have the same proportions as the original. To enlarge the original, extend the length of the diagonal.

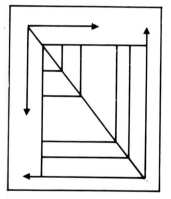

FIGURE 5–1

Grid, Letterblock: (see figure 5-2)

A diagonal combined with a grid enables placement of a design on a receding surface. A letter on an alphabet block is a good example. Use a grid on a non-receding view of the block; then transfer that grid to the receding block face by copying grid markings on the forward vertical edge. Take these to the vanishing point used for the receding block face; then draw a diagonal across the receding

face. At points where it crosses a receding horizontal, draw a vertical. The grid is transferred. Transfer the design using the nonreceding grid as a guide.

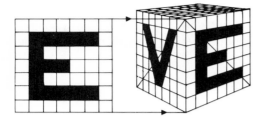

FIGURE 5–2

POSITION CHANGES WITH PROPORTIONS UNCHANGED

Horizontal and Vertical Changes

When two objects on a level surface are located the same distance from the picture plane, their bases will be on the same horizontal line. Their comparative heights can then be measured by a parallel horizontal line; widths may also be measured.

Any object may be repositioned horizontally across a drawing without changing its distance from the picture plane, its proportions, or its size.

Any measurement taken on a horizontal may be repeated as a vertical or slanted line of the same length if its base touches the original horizontal or an extension of it which has established its distance in space.

To repeat a height or width at a different distance, take both ends of the measurement toward a VP. Any horizontal or vertical along this path will repeat the original measurement.

In this way height-to-width proportions are established, and objects may be moved in a drawing without distorting their proportions. *From the known length of only one horizontal or vertical line, proportions are established for the entire drawing.*

Depth Changes with Vanishing Points

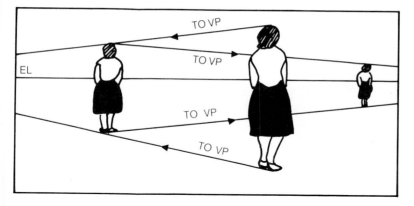

FIGURE 5–3

Any known height can be moved back, forward, or across a drawing by using vanishing points when a line is drawn from the top and bottom of the height to a VP. A vertical may be drawn anywhere between these two lines, and it will indicate the original height placed farther away in space. Figure 5–3 shows one person moved to several positions. Draw a figure moved to at least three different positions in distance. Use at least two VPs.

Positioning People; Shortcut

This shortcut may help you to draw a group of adults at various distances in space. If you and the adults are standing on a level surface, their heads will be approximately on your eye level. You can thus draw people in proportion to each other when there is no architecture or other reference for their height. People can be drawn very small (far away) or quite large (close to you), but if their heads are on or very near your eye level, they will appear to be standing on the same level surface. If you are seated and a group of adults is standing, their waistlines will be on your eye level.

Draw an interior or exterior view showing a group of people at various distances. Indicate whether you are sitting or standing. When you have finished, check to be sure that the people are well proportioned to each other and to the architecture.

65

Draw from an actual scene or from one of the following photos (figs. 5–4 and 5–5)

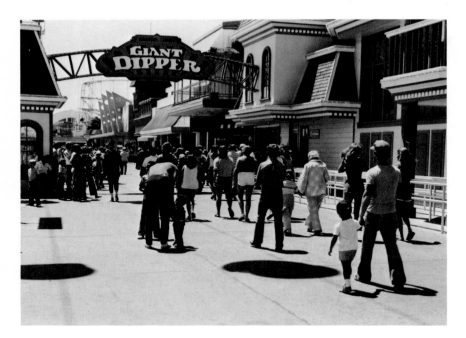

FIGURE 5—4

FIGURE 5—5

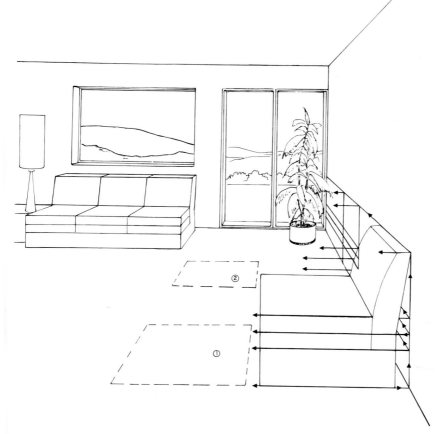

FIGURE 5—6

Moving a Chair

Any object may be repositioned horizontally across a drawing without changing its distance from the picture plane or its size. In figure 5—6 draw the chair moved out to the center of the room without changing its distance from the picture plane. It will occupy square 1. When you have finished, check to be sure that the height is the same in both positions and that they are the same distance from the bottom of the drawing. Now draw the chair moved to square 2 by projecting it from square 1 back to the vanishing point.

To ensure accuracy, draw a horizontal from the base of the chair to the wall. Draw a horizontal from each height division—back, seat, and cushions,—to the vertical

on the wall. Now draw these heights along the wall toward the VP. To place the chair farther back in distance, draw a horizontal on the floor at the desired position, then vertically up the wall. Wherever it intersects a height marking, draw another horizontal back to the repositioned chair.

Commercial Designing Aids

Interior designers often use acetate for their client presentations. You can simulate this by using tracing paper over your drawing. To save time doing commercial work, grids may be purchased that divide standard floors, walls, and ceilings into equal squares in one-point or two-point perspective. The acetate is taped over the grid and the designer works directly on the acetate.

Drawing a Room Interior

You now have all the information you need to draw a room interior in one-point perspective with depth dimensions estimated.

We have used two repositioning devices that may also be used for the original placement and proportions of an object in a drawing:

1. *Any object may be moved horizontally across a drawing without changing its distance from the picture plane or its size.*
2. *Any object may be moved forward or back by projecting it forward from a vanishing point or back to a vanishing point without changing its proportions to the rest of the drawing.*

When drawing an interior, proportions for architectural details and for furnishings are taken from the back wall in one point and from the farthest corner in two point.

Standard ceiling height is 8 ft. A vertical on the back wall may be divided in half for a 4-ft level, in half again for 2 ft, and once again for a 1 ft equivalent. Using the various proportioning devices, draw a room interior in one-point perspective.

Figure 5–7 is an example. Include at least one door, one window, and one piece of furniture or counter touching a wall and one piece of furniture not touching a wall. This can be any kind of room you want, but keep furniture and accessories appropriate to the room's purpose and in believable proportion.

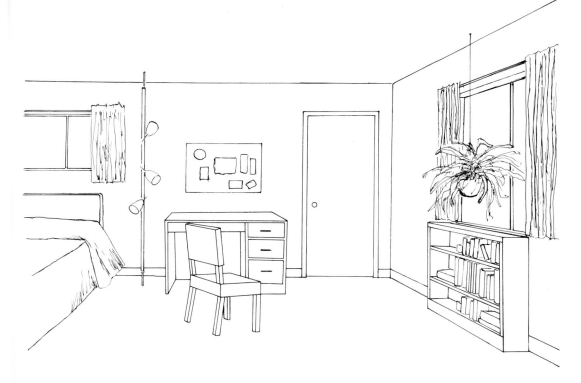

FIGURE 5—7

1. First, draw the back wall in one point showing the floor and ceiling.
2. To place your eye level on the back wall, decide whether you are seated or standing. If you are sitting, you eye level is about halfway up the wall; if standing, about two-thirds of the way up. Draw it.
3. Since this is one-point perspective, the vanishing point should be centrally located somewhere on the eye level.
4. From the vanishing point, extend forward through the top and bottom corners of the wall to show a side wall.
5. A standard door height is 6 ft 8 in., which is a little more than three fourths of the wall height. Approximate that height and draw the top of the door on the back wall. The door will be 2 to 3 ft wide, and since the width is not receding, it can be taken from the height measurement to complete the door.
6. Window height is usually the same as door height. Put the window on the side wall. To do this, extend the door height horizontally across to the corner. Through this point, a line projected forward from the vanishing point will

provide a line on the side wall for the height of all doors and windows. Windowsill height varies, but is often 3 to 4 ft from the floor. Approximate this at the back corner and project it forward on the side wall. Make the window any width you wish.

7. Furniture size is estimated on the back wall at the corner. Draw the area a piece of furniture would cover on the wall and the floor. These surfaces can then be projected forward, backward, or across with lines from the vanishing point through each corner. Keep lines light until you have found the desired position.

8. If you wish to draw a piece of furniture not parallel to the walls, it will be in two point. Be sure the vanishing points are far apart and on the same eye level as the rest of the room.

MEASURING DEPTH

So far, depth dimensions have been estimated; now you will learn how to exactly calculate them. These might include the width of a door on a receding wall, the depth of the first square of a sidewalk, or the proportions of the riser to the tread on a stair step. Some drawing purposes, however, require exactly correct proportions, and some further require a stated relationship to full-size measurements. This is called *scale drawing* or "drawing to scale." In these drawings a notation is provided showing how many inches or fractions of an inch equal one foot. Scale drawing is essential in architectural planning and interior designing. Plan views and nonreceding elevations are done by measurement, but they are difficult to visualize in terms of the three-dimensional space being described, whereas a perspectective drawing in scale will immediately and clearly show the intent of the design.

Principles to Remember

1. Nonreceding dimensions can be measured.
2. Receding dimensions can be measured when they are seen in a nonreceding view, as in a side view, sometimes called a profile, or from the top, sometimes called a plan view.
3. The perspective effect diminishes with distance; therefore, *it is important to establish the distance from which you are viewing.*

Terms to Remember

The visual field is like a *cone*, and is called *the cone of vision.* The tip of the cone is at your eye and the circle end is on the picture plane. This is called the *circle of vision.* You may draw anywhere within this circle without distortion.

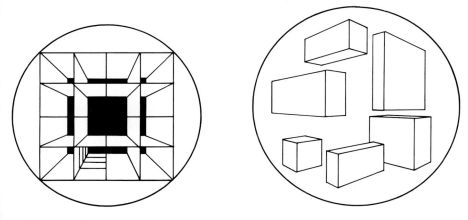

FIGURE 5—8

Figure 5—8 shows some arrangements of forms in one and in two-point perspective within the *circle of vision*. The center of the circle is called the *center of vision (CV)*. It is located on the eye level. The *line of sight, also called the center line of vision* is the distance between your eye and the center of vision. It is perpendicular to the eye level. The tip of the cone is called the *station point (SP)* because it is where your eye is, or where you are stationed.

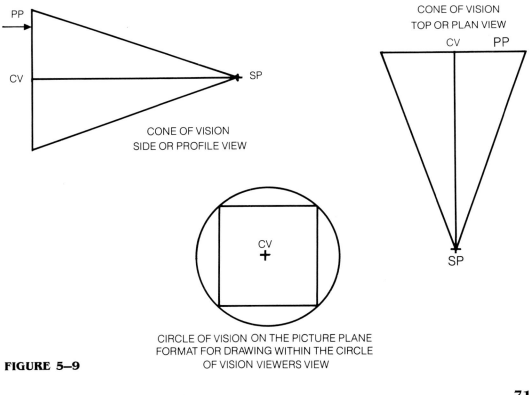

PP

CV

SP

CONE OF VISION
SIDE OR PROFILE VIEW

CONE OF VISION
TOP OR PLAN VIEW

CV PP

SP

CV

CIRCLE OF VISION ON THE PICTURE PLANE
FORMAT FOR DRAWING WITHIN THE CIRCLE
OF VISION VIEWERS VIEW

FIGURE 5—9

Measuring the line of sight tells you how far you are from the object being drawn. To measure this distance, it must be seen from a nonreceding view, either as a side (profile) view or as a top (plan) view. Figure 5–9 shows three views of a cone of vision. In the side view and in the the top view, the picture plane is seen as a straight line; in both views the line of sight measures the same.

The Angle of Vision An experiment in chapter 1 demonstrated diminishing size with increased distance by holding the hand at three distances from the eye. In figure 5–10, a diagram using a cube shows more precisely what was happening. This profile shows an eye looking at the same size cube from several distances. As the distance from the eye increases, the angle of vision decreases.

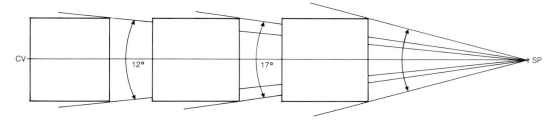

FIGURE 5–10

To see the entire side of the cube closest to the eye, the angle of vision used is 27 degrees; a 17-degree angle is needed to see the middle cube and only 11 degrees for the far cube. Because the far cube uses a smaller part of the cone of vision, it appears smaller to the eye. The size of the circle of vision on the picture plane depends on two factors: (1) the length of the line of sight and (2) the angle of vision used.

For some drawing purposes a 60-degree angle of vision is acceptable as maximum closeness without distortion; for other purposes the angle should be no greater than 45 degrees; for some, 30 degrees or less is preferable. The 60-degree angle will probably be the one you use most for general purposes. To establish it, draw the line of sight at least twice the length of the radius of the circle of vision. This is done by placing the SP vertically below the CV as in the top view, figure 5–9, or by placing the SP to the right or left on the eye level. The length of the line of sight is the same in either position. This will give you slightly less than 60 degrees. If you want to be more precise, measure the angle with your protractor.

If you want to work within a 45-degree limit, make your line of sight three times the length of the radius, yielding slightly less than 45 degrees. If you make it four times the radius, you will be within a 30 degree angle limitation.

THE CUBE IN ONE-POINT PERSPECTIVE

The cube is a convenient shape to work with since all its sides measure the same. Any nonreceding edge of the cube can be measured to give you the measurement of any receding edge. Multiples of the cube in any direction can give accurate measurements of receding irregular shapes.

Drawing the Cube

Here is a simple and accurate method for drawing any cube in one-point perspective:

1. Draw the eye level and vanishing point.
2. Place the station point on the eye level at a distance from the VP which is at least twice the distance from the VP to the outer limit of the drawing, vertically or horizontally, whichever is greater. This will place the cube within a 60-degree angle of vision.
3. Draw the front (nonreceding) face of the cube and its receding edges to the VP.
4. Draw lines from the station point to the corners of the cube (fig. 5–11).

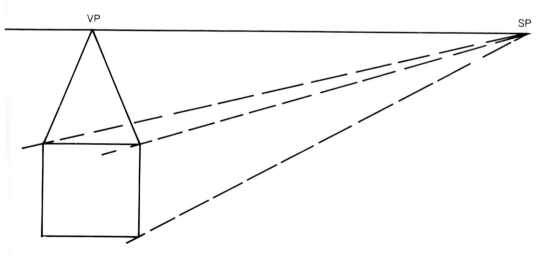

FIGURE 5–11

5. At the point of intersection with the receding top, establish the depth with a horizontal to complete the cube (fig. 5–12)

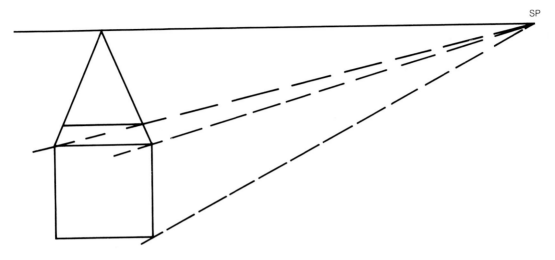

FIGURE 5–12

Figure 5–13 shows some cubes in one-point perspective.

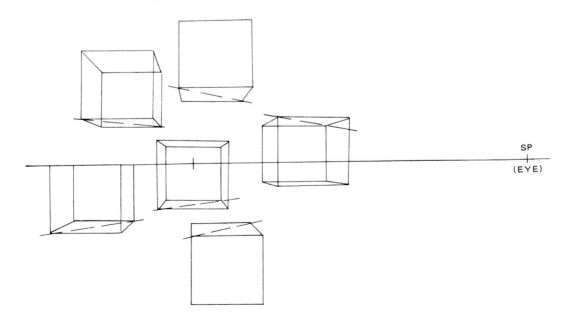

FIGURE 5–13

Now draw some one-point cubes of your own in exact proportions. Each face of each cube is a square, but only the top or bottom needs to be calculated.

Drawing a Square

A chessboard (fig. 5–14), since it is square, can be thought of as the top face of a cube. Find the eye level, vanishing point, and station point. (Answers are at the end of the chapter.)

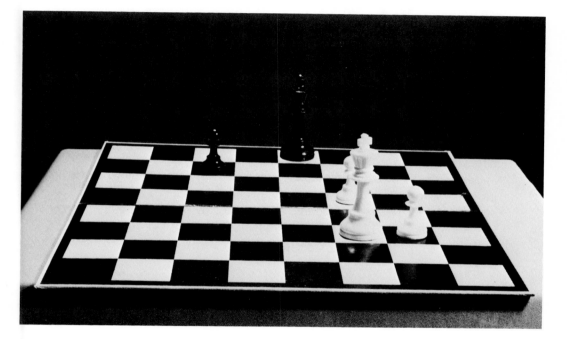

FIGURE 5–14

Now draw a chessboard (eight squares by eight squares). Think of it as the top face of a cube; it will not be necessary to draw the whole cube, only the top.

1. Start by drawing the front edge, eye level, vanishing point, and station point, twice as far from the VP as the outer limits of the drawing in any direction.
2. Draw a line from the SP to the front corner on the opposite side. Its intersection with the receding depth establishes the back edge of the board.
3. The front horizontal is divided by measurement. These divisions go to the VP.

4. Where the diagonal crosses the receding lines, draw the horizontal divisions.

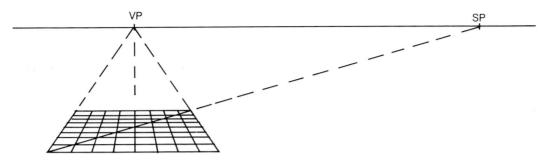

FIGURE 5–15

Scale Drawing

Scale drawing, or *drawing to scale,* is a way of drawing with measurements reduced in a stated proportion. Many architectural and engineering drawings are done in this way so that measurements other than those given may be taken directly from the drawing for manufacturing purposes. When scale drawing is used in perspective, however, its purpose is to show very accurately what the finished product will look like. In this instance the scale is measured on the plan view. The scale is stated. This is a proportion stating the drawing measurements compared to the intended size of the object represented, such as ¼ in. = 1 ft.

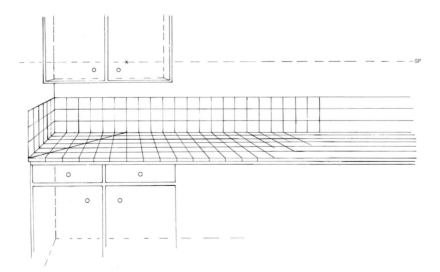

FIGURE 5–16

Draw a tiled kitchen counter in one-point perspective by projecting forward from a one-point VP as in figure 5–16. Make this a scale drawing using these measurements:

The eye level is 5 ft from the floor.
The counter is 3 ft high and 2 ft deep.
The tiles are 4 in. square.
You are standing 8 ft. from the back wall.
The scale at the back wall is ¾ in. = 1 ft.

1. Draw the eye level and VP.
2. Locate the bottom of the wall as follows: ¾ in. = 1 ft, so 5 ft = ¾ in./ft x 5, or 3¾ in. Therefore, draw the bottom of the wall 3¾ in. below eye level.
3. The back of the counter top should be located in the same way: 3 ft x ¾ in./ft = 2¼ in. Therefore, draw the back of the counter top 2¼ in. above the floor.
4. Locate the SP as follows: 8 ft x ¾ in./ft = 6 in. to the right of the VP on the eye level.
5. Measure the divisions for the tiles (4 in. = ¼) along the back wall of the counter top, with one division directly below the VP. Project lines from the VP through these divisions forward.
6. Draw the angle of vision line from the SP through the division point directly below the VP and extend it beyond, crossing six receding lines (2 ft). At the 2 ft intersection a horizontal forms the front of the counter.
7. Draw horizontals where receding lines intersect the diagonal, and extend them to the end of the counter.
8. Continue three rows of tile up the back wall and up the side wall at the corner.
9. Add drawers below and cupboards above.

THE CUBE IN TWO-POINT PERSPECTIVE

Drawing the Cube

Drawing the cube in two-point perspective is a different problem because you need to establish depth for two receding dimensions that are not always equally visible. This can be demonstrated by rotating a cube on a table. Your position (station point) remains the same in front of the cube, but as the cube rotates, its vanishing points slide back and forth along your eye level with each change in position. As a pair of VPs moves along the eye level, the distance between them changes with closeness to the CV. However, no matter where they are, a line from each will meet at the SP, forming a right angle. This right angle is equivalent to the corner of

the cube seen in a plan view, and the lines that form it are drawn parallel to corresponding edges of the plan view of the cube. To draw it, refer to figure 5–17.

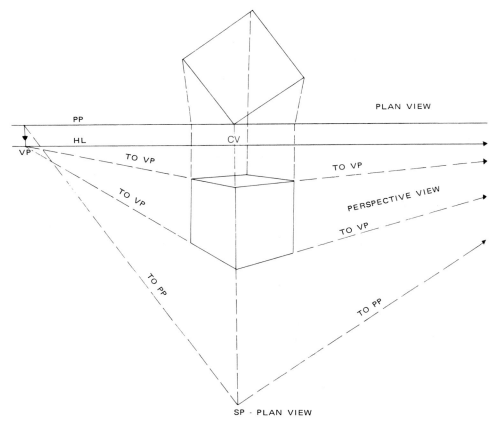

FIGURE 5–17

1. Draw the plan view first with the front corner touching the picture plane (PP). The PP is seen as a line because it is seen from above in the plan view.

2. Draw the horizon line (HL). If the entire drawing is to be below eye level, one line may serve for both PP and HL; otherwise draw a horizontal HL conveniently below the PP.

3. Draw the line of sight as a vertical extending down from the PP at the front corner of the cube.

4. Place the SP on this line low enough so that its distance from the HL will be at least twice the distance between the center of vision (CV) on the HL and the outer limits of the drawing in any direction.

5. Locate VPs by drawing lines from the SP parallel to each receding side of the plan view cube. Take these lines to the PP then drop them vertically to the HL.

6. Draw the vertical front edge of the cube on the center line of vision. Its height measures the same as its depth in the plan view. Draw its receding sides toward VPs on the HL.

7. Limit its depth on each side by drawing lines from each corner of the plan view toward the SP and stopping at the PP. Then continue them vertically down to intersect the cube sides. Complete the back edges of the cube.

Drawing a Square

Theoretically, all you need to establish the cube is the plan view of the two front sides, but locating the back corner helps to check accuracy. Any single face of a cube can be drawn to give you a square area on a flat surface—floor, wall, or ceiling; then, a single square can be multiplied in any direction by using diagonals. Instead, it is sometimes faster and more accurate to extend the plan view with equal divisions and project these. Try this method by drawing a sidewalk (multiples of the bottom face of the cube) (see fig. 5–18)

Extending cross divisions gives a checked surface for a floor, ceiling, or wall.

FIGURE 5–18

79

Forms with Angles Other than 90 Degrees

The same method can be used for drawing a fence that changes direction, but not at a right angle (fig. 5–19). Think of it as though you were drawing only one receding face of a cube.

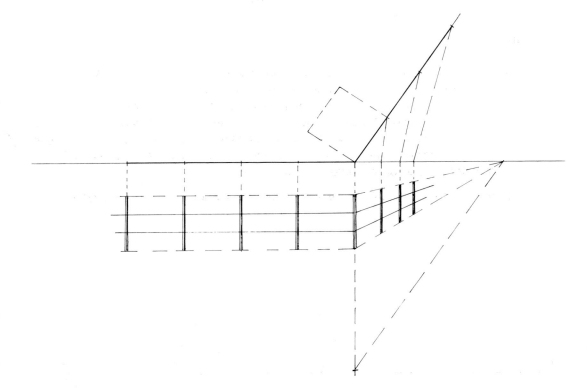

FIGURE 5–19

These fence posts are evenly spaced because they are evenly spaced on the plan view, but as you can see, this method will work just as well with unevenly spaced divisions.

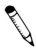

1. Draw the HL, here the PP; draw the plan view on the PP.
2. The VP is at the right on the HL; the SP is on a vertical below the fence corner. Locate either by choice; then find the other by drawing a line connecting them which is parallel to the plan view receding direction.
3. Above the SP draw the top and ground lines of the fence, horizontal to the corner, then receding to the VP.
4. Equal sections between receding posts are determined by measurement on

the plan view. Draw a line from each division toward the SP stopping at the PP, then continuing straight down to the ground line of the fence.

5. Complete the drawing with wires or crosspieces as you wish.

Combined Cubes

Any rectilinear form can be drawn as a combination of cubes, and any irregular form can be accurately drawn by encasing it in a cube or combination of cubes. This is why artists speak of "blocking in" a rough drawing—they are estimating the space for any given object by drawing the block (cube or cubes) that encases it.

Scale Drawing of Stairs

Starting with a block, draw a set of stairs in two-point perspective in scale as in figure 5–20.

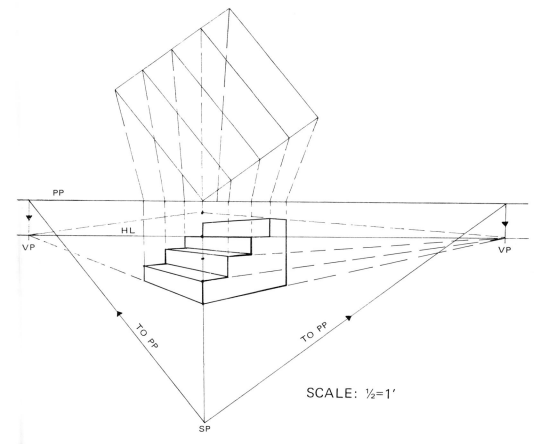

FIGURE 5–20

1. First, establish the proportions and scale. Most steps have risers no more than 6 in. high and treads at least 9 in. deep. A stairway should be at least 3 ft. wide. Using these dimensions a block of four stairs would measure 3 ft wide, by 2 ft high, by 3 ft deep. A convenient scale might be 1 in. = 1 ft. Figure 5-20 is half this size.

2. Draw the plan view touching the PP. Draw it 3 in. (3 ft) on the left for the stair width and 3 in. (3 ft) on the right for the stair depth, because each tread is 9 in. deep or ¾ in. In scale, ¾ in. x 4 = 3 in. Measure the treads along this side.

3. Draw the HL conveniently below the PP, and the line of sight through the closest corner of the plan view. Locate the SP on it at least twice as far below the HL as the distance between the center of vision on the HL and the outer limits of the drawing in any direction.

4. Draw lines from the SP to the PP parallel to the receding edges of the plan view, then drop vertically to the HL to establish VPs.

5. Next draw the closest vertical edge of the block of stairs. Since there will be four risers, 6 in. each, the block will be 2 ft high, and in our scale that will measure 2 in. Divide this line into four ½ in. segments, one for each tread. Take these height divisions to VPs on each side.

6. Draw a line from each corner and each step division on the plan view toward the SP, stopping at the PP, then vertically down to intersect the receding lines. Complete the stairs.

7. Be sure to note the scale you have used.

Scale Drawing of Room Interior

By this time, you should be able to draw a room interior in exact proportions and correct scale. One-point perspective is a little easier and faster than is two point because there is only one receding dimension, but two point is almost as easy and fast. Since interiors are usually shown in two point, draw an interior in two point (see fig. 5–21)

1. First, decide the scale (here, 1 in. = 8 ft at the back corner).
2. Draw a plan view of the back corner of the room in scale.
3. Then draw a horizontal PP touching and below it.
4. Draw a horizontal HL conveniently below the PP.
5. Draw a vertical line of sight from the back corner through the PP and extend it below the drawing.

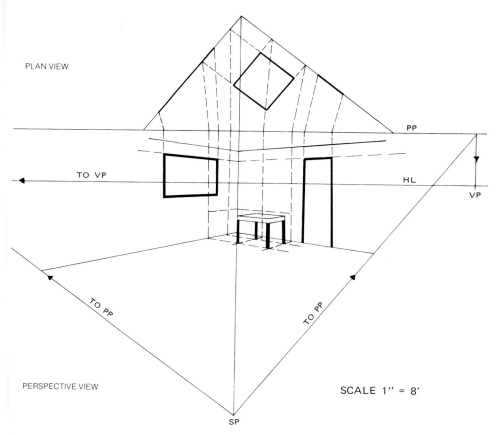

PLAN VIEW

PP

TO VP

HL

VP

TO PP

TO PP

PERSPECTIVE VIEW

SCALE 1″ = 8′

SP

FIGURE 5–21

6. Place the SP on this line at least twice as far below the HL as the distance between the center of vision on the HL and the outer limits of the drawing.

7. Draw lines from the SP to the PP parallel to the walls in the plan view, then drop vertically to the HL to establish the VPs.

8. From the back corner of the plan view draw a line toward the SP stopping at the PP, then vertically down to cross the HL and establish a comfortable eye level; (here you are standing). The height of the back corner will be in scale (here, 8 ft = 1 in.)

9. Project floor and ceiling lines forward from each VP. Height of doors, windows, and furniture in the room can be measured on this corner and projected along the wall, then forward into the room.

10. Width of doors, windows, and furniture in the room are measured on the plan view. From each such division draw a line toward the SP stopping at the PP then vertically down to the wall. These may then be projected forward into the room.

From here on the drawing is up to you. Figures 5–22 and 5–23 may be used for ideas if you wish. The amount of time it takes will depend on the amount of detail you want to include. Remember that details are less noticeable across the room and are often merely suggested, but whatever you include should be in correct scale.

Here are a few standard measurements for reference:

doors:	6 ft 8 in. high, width 2 ft to 3 ft (2½ ft average)
windows:	the same top height as the doors; sill height and width, no limit of variation.
table heights:	coffee tables, often 15 in.
	game tables, 26 in.
	dining tables, 30 in.
chairs:	seat height, 16 in. to 18 in.
kitchen counters:	36 in. high, 24 in. deep
stairs:	no more than 6 in. risers; no less than 9 in. treads
bed height:	2 ft
chest of drawers:	many variations, often 3 ft to 4 ft high

Please include at least one window, one door, and at least one piece of furniture not touching a wall. Make it as attractive as possible, with the furniture arranged conveniently and comfortably, and appropriately selected for the intended purpose of the room. Before adding shading (if desired) use the checklist to be sure your walls and furniture are correctly proportioned and positioned.

Instead of erasing construction lines, the finished drawing may be an overlay on tracing paper or acetate.

CHECKLIST

1. Are all horizontal lines exactly horizontal, and are the verticals exactly vertical?
2. Do all receding edges go to the proper vanishing point?
3. Is the eye level consistent with a sitting or standing view?
4. Is any piece of furniture occupying the same floor space as any other?
5. Is all furniture within the walls of the room?
6. If projected back to a wall, would each piece of furniture be the correct height and width?

If you have answered yes to all of these except number 4, you have drawn a room in correct proportion and scale.

FIGURE 5—22

FIGURE 5—23

This is a self-test on terms used in this chapter. In the margin before each term in the left-hand column place the letter for its definition selected from the right-hand column.

1. proportion	A. plan
2. pleasing proportions	B. undistorted view on the picture plane
3. measuring line	C. visual field
4. diagonal	D. profile
5. grid	E. eye location
6. side view	F. device for changing size or direction
7. top view	G. harmony
8. cone of vision	H. stated proportion
9. circle of vision	I. from eye to center of vision
10. center of vision	J. comparison
11. line of sight	K. outside limits of cone of vision
12. station point	L. center of circle of vision
13. angle of vision	M. device for changing size
14. scale drawing	N. device for transferring a design

1. J; 2. G; 3. F; 4. M; 5. N; 6. D; 7. A; 8. C; 9. B; 10. L; 11. I; 12. E; 13. K; 14. H.

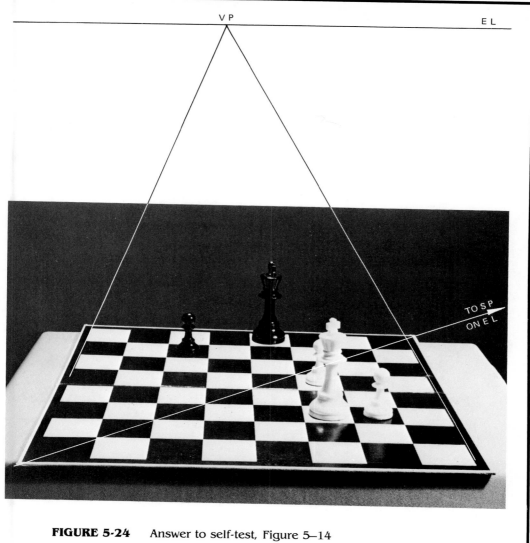

V P

E L

TO S P
ON E L

FIGURE 5-24 Answer to self-test, Figure 5–14

6

the
slanted
plane

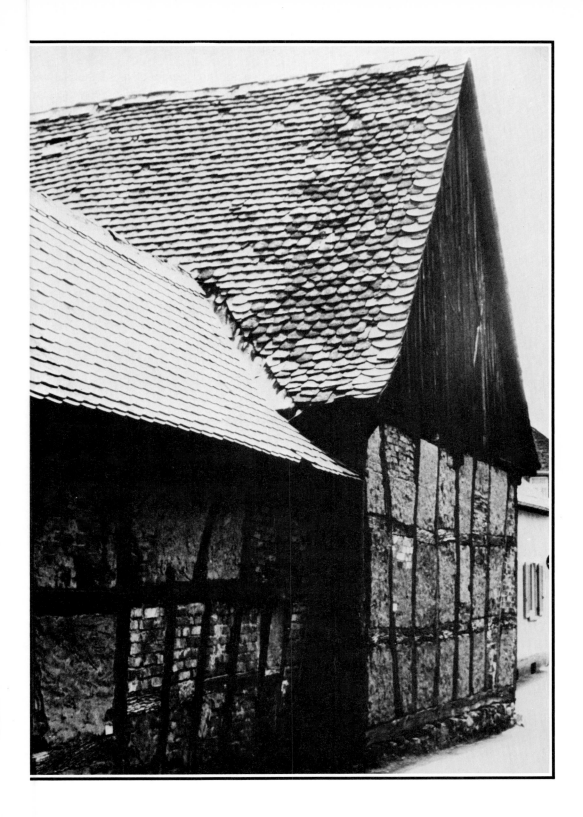

DEFINITION

Chapter 3 refers to three-point perspective as the "perspective of the slanted plane" because it is used when the height dimension is receding, thereby creating a slanted plane. The three-point vanishing point (3 pt VP) for that slanted plane will be vertically aligned either above or below the eye level VP it would have if it were flat (level). How far above or below depends on the *steepness* of the slant. If the slant is very steep, the 3 pt VP will be far above or below the eye level VP; if the slant is not very steep, the 3 pt VP will not be very far above or below eye level VP. The *direction* of the slant determines whether the 3 pt VP is above or below the eye level VP. If the slant is going down as it recedes, the 3 pt VP will be below the eye level VP. If the slant is going up as it recedes, the 3 pt VP will be above the eye level VP. Figure 6–1 contains some slanted planes. Find them and their vanishing points. Answers are at the end of the chapter.

FIGURE 6–1

USING THE SLANTED PLANE VANISHING POINT FOR CONSTRUCTION

Roofs

When drawing a building with a slanted roof, the receding dimensions of the building recede toward eye level VPs, but the ascending roof plane recedes toward a slanted plane VP vertically above the eye level VP. In this case the slanted plane VP is often used to help construct the roof.

90

Roof on a Two-Point Perspective Building To see how this works, draw a simple building in two-point perspective and add a slanted roof. Here are the steps to follow:

1. Start with the eye level a little above center on your paper with VPs near the edges.
2. If you are standing on the same ground level as the building, your eye level will be at about two-thirds of the wall height. The closest height edge is first, crossing the eye level with about one-third of it above eye level.
3. Extend receding horizontals to the VPs at the top and bottom on both sides.
4. Draw a vertical height line to limit each side. Now you have a simple rectangular building without a roof as in figure 6–2.

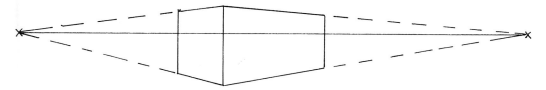

FIGURE 6–2

5. To add the roof, find the center of one side by using diagonals.
6. Then extend a vertical upward from the center above the top of the wall. The peak of the roof will be on this line. The higher it is, the steeper the roof will be.
7. Next, establish the peak and connect it with the two top corners at the end of the building.

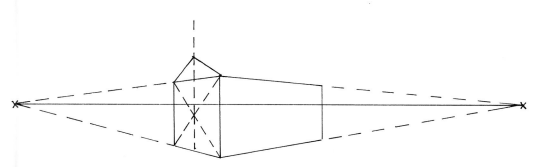

FIGURE 6–3

91

8. The roof ridge is parallel to the top and to the bottom of the long side of the building, so it will recede to the same VP. Where does it stop?

9. To find the far edge of the slanted plane and intersect the ridge, extend the previously drawn slanted plane edge back to a 3 pt VP vertically above the eye level VP.

10. Now draw another slanted plane line from the top far corner of the building to the same 3 pt VP. This line will intersect the ridge and form the far end of the roof.

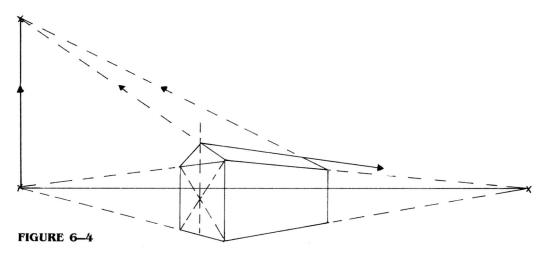

FIGURE 6—4

11. Put eaves on the roof by extending the slanted lines down. Remember that all receding lines parallel to each other go to the same VP. The roof is complete.

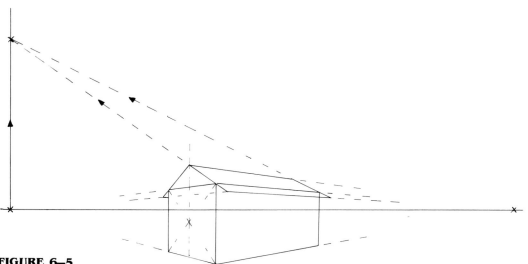

FIGURE 6—5

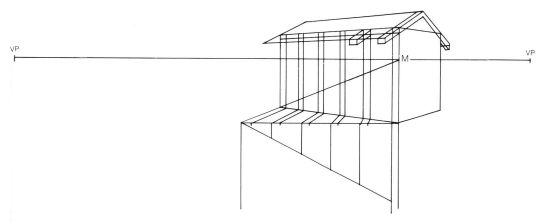

FIGURE 6—6

Placing Rafters

Using the same procedure, draw the shed in figure 6–7. To place rafters evenly on a receding wall,

1. Draw a nonreceding view of the wall length as in figure 6–6.
2. Subtract from this length the width of one rafter.
3. Divide the remainder of the length into equal segments, one for each remaining rafter. Each segment will contain a rafter and a space.
4. Mark the remaining rafters, making sure there is one on each end of the wall.
5. Using a measuring point on the eye level of the perspective view, place the rafter spacings at the top of the wall.
6. From the slanted plane VP used for the roof, project the rafters forward and cover them with an extension of the roof. Eaves and rafters are complete.

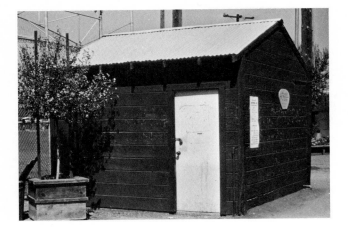

![pencil icon] **FIGURE 6–7**

Roof on a One-Point Perspective Building Now draw the same shed in one-point perspective, showing just the front wall with the roof slanting back. Remember that in one-point perspective the vanishing point is on your center of vision; so if you cannot see either side of the building, the vanishing point is somewhere within it on the eye level. The slanted plane vanishing point for the roof is vertically over the eye level vanishing point. The corrugations on the roof all go to the same vanishing point. Now draw a similar shed very close to it, also in one point perspective, using the same vanishing points. On this one you will see the front and one side, or part of it (fig. 6–8).

Note the method shown here for finding the depth of the second building.

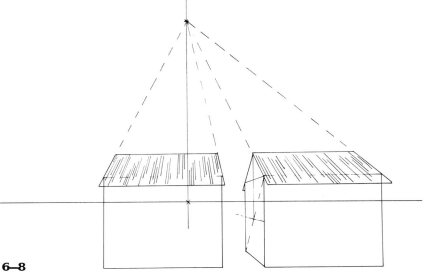

FIGURE 6–8

94

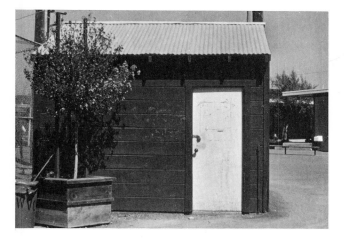

FIGURE 6—9

Using the same procedure, draw the shed in figure 6–9. Since these rafters are not on a receding wall, they may easily be placed by direct measurement, or by using a measuring line as in the previous drawing.

Remember to subtract one rafter width before dividing the wall into equal segments. Use the checklist from the previous drawing.

Box Flaps

Slanted plane vanishing points can be used to construct the open flaps of a box. Figure 6–10 is an example in two point:

1. Draw the box, in two point.
2. Now draw the angle of the largest flap. Extend it back into space to its 3 pt VP. Draw its opposite edge in the same way.
3. The tuck-in flap goes in another direction. Is its slanted plane VP above or below eye level? Move along the receding slant from the corner closest to you and you will find it.
4. Now draw the other two flaps. The box is complete.

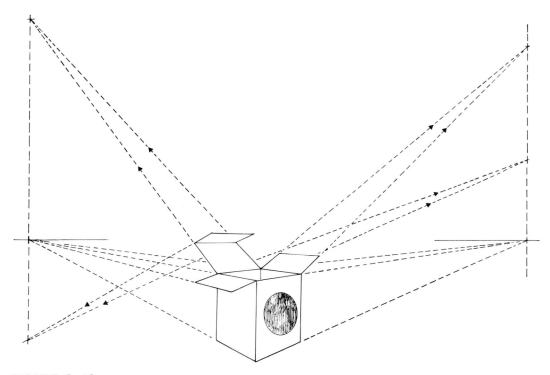

FIGURE 6–10

Now turn the box so that you see it in one point perspective (fig. 6–11). Here the large flap of the lid is still slanted, but its slant is not receding from the picture plane, so it will not have a slanted plane vanishing point. The other two flaps, however, are slanting away from the picture plane, so each of these will have a slanted plane vanishing point. Draw the box in this position. Then use the checklist for the previous drawing.

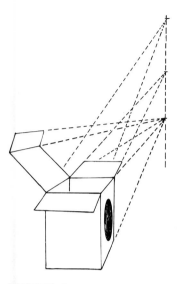

FIGURE 6–11

The Slanted Plane as Ground

Roads Sometimes a slant is the ground plane. When a road or street goes uphill or downhill, the three-point vanishing point must be used to locate the slant properly.

Figure 6–12 shows a straight country road. Some parts of it are uphill and some downhill, with flat areas in between. Think of the road plane in segments divided by horizontals. Locate the uphill, downhill, or level vanishing point for each section and label each *up, down,* or *level.* You will find three vanishing points vertically aligned. Turn to the end of this chapter for answers.

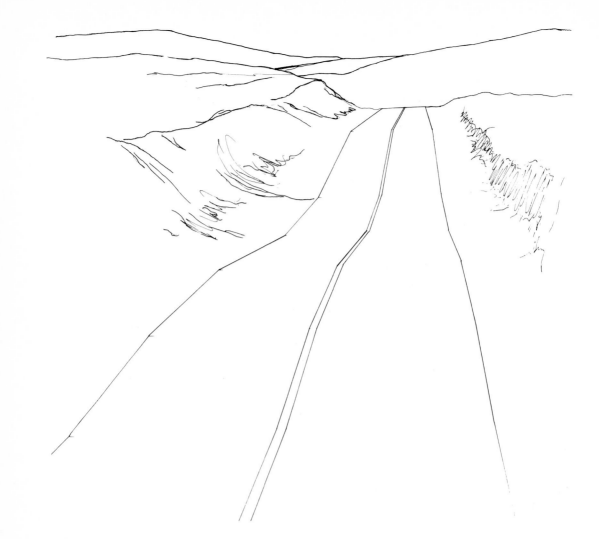

FIGURE 6–12

Now try drawing a slanted ground plane by drawing a city street on a hill, level only at cross streets (fig. 6–13).

1. Start with your eye level and vanishing point.
2. Now near the bottom of your paper, draw a level section of street receding to the eye level VP.
3. Draw a horizontal line across it where it stops. This will help you keep track of where you change slants and will show the correct width for the next segment.
4. Now take the street downhill to a downhill VP vertically below the eye level VP, ending with another horizontal line.
5. A level section for a cross street is next.
6. The next section goes uphill to an uphill VP vertically above the eye level VP.
7. Then a level section.
8. Now uphill. Take it above eye level if you wish.

When a building is erected on a hill, its ground line follows the line of the hill, but the building is constructed with level floors, ceilings, windows, and doors. Consequently, except for the ground line, all receding edges of buildings will go to the eye level vanishing point. It is quite different with cars and trucks on a hill. They are not level, so their receding edges go to the same vanishing point as the street they are on.

Now add some buildings to your drawing and at least one car or truck.

You can further develop your drawing by

1. Placing buildings on both sides of the street. To keep the buildings in proportion, measure horizontally from the buildings across the street.
2. Varying the heights of buildings, adding windows and doors.
3. Providing traffic lane lines, crosswalks, and pedestrians.
4. Adding cars or trucks. A passenger car is about 4½ ft high, 5 ft wide, and 15 ft long. Vans, buses, and trucks are proportionately larger. Size judgements are made from dimensions already drawn. Remember that a car on a slanted plane recedes to that plane's vanishing point.
5. Shading the drawing, keeping the light direction consistent.

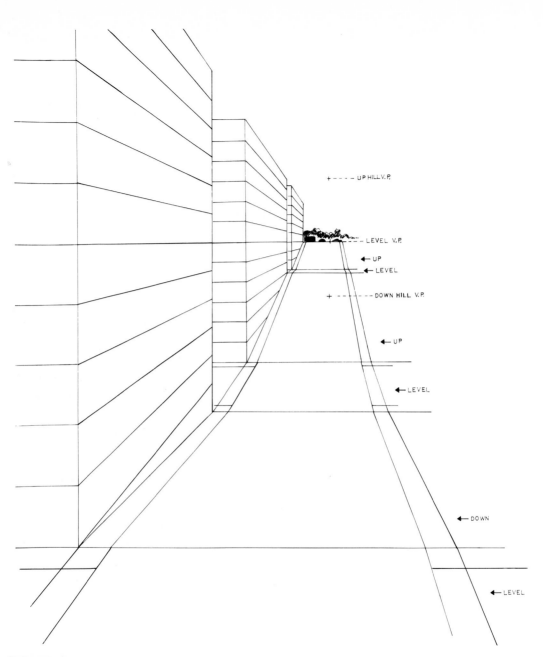

The labels on the figure read:
- UP HILL V.P.
- LEVEL V.P.
- UP
- LEVEL
- DOWN HILL V.P.
- UP
- LEVEL
- DOWN
- LEVEL

FIGURE 6–13

Here receding lines on buildings represent floors (10 ft). The sidewalks are 5 ft wide and the street is 50 ft wide. These proportions are established by measuring a nonreceding vertical and horizontal at the same placement in depth. To apply

these proportions to other places closer or more distant, use the VP. Draw cars and people in proportion.

Figure 6–14 is a photo of a San Francisco street. Try to draw this one freehand, but using your straightedge if you need it.

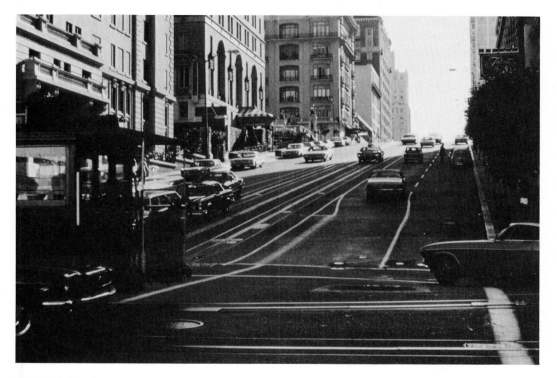

FIGURE 6–14

1. Where are you standing?
2. Locate your eye level (level receding edges will help you).
3. This is in one point, so your eye level vanishing point is directly in front of you at the point where the level receding edges meet.
4. How far below or above eye level are the cross streets?
5. To draw the general shape of the street you may find it easiest to start at the bottom of your paper and work back to the VPs.
6. Locate the VP for each slant as you come to it.
7. Include some of the buildings and cars.
8. If you wish, you can use your softest pencil to darken areas that are dark in the photo.

WEDGE

In Two Point

Whenever it is convenient to draw the flat surface directly underneath a slanted plane, you may find the wedge helpful. This is an easy way to place the slanted plane exactly where you want it, and you don't need the three point vanishing point to draw the edges of the slant correctly. The three point vanishing point still exists, however, and may be used to check drawing accuracy if you wish. The wedge concept is often convenient for drawing ramps, awnings, stairs, pages of an open book, or wedges of cheese or cake. Draw a wedge in two-point perspective (see fig. 6–15).

EYE LEVEL

FIGURE 6–15

1. First, draw the eye level and the VPs far apart.
2. Then draw a rectangle below eye level, like the bottom of a box, receding to the eye level VPs.
3. Make this wedge slant up as it recedes by drawing a vertical at the back corner on the right. The back corner on the left is farther away than the one on the right, so a vertical here is limited in height by a line from the top of the right vertical to the left VP. Now you have the back of a box.
4. The wedge is completed by drawing the edges of the slanted plane on each side from the top of the back to the bottom of the front.
5. You can check to see how accurate your drawing is by continuing the edges of the slanted plane. They will meet at a VP vertically above the right-hand eye level VP.

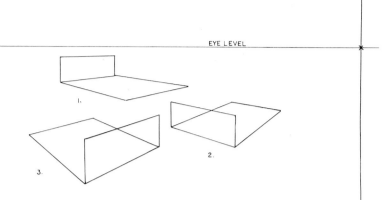

EYE LEVEL

1.

2.

3.

FIGURE 6–16

Complete the wedges in figure 6–16 and find the vanishing points. Answers are at the end of the chapter. Now draw some wedges in other positions, in two point perspective. Include some without a slanted plane VP.

In One Point

When a slanted plane vanishing point is used with one-point perspective as with the roofs of the sheds in one point, there is no two point, just one and three. Remember that the slanted plane vanishing point is used only when a height is receding from the picture plane. To draw a wedge in one point see figure 6–17.

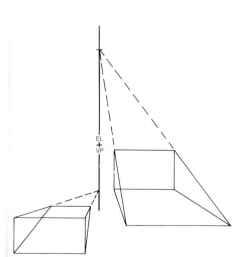

EL
+
VP

FIGURE 6–17

103

1. First, draw the eye level and a VP on it somewhere near the center.
2. Next draw a receding rectangle in one point. This is the bottom of the wedge.
3. Now draw the height verticals, both on the back or both on the front, and add a horizontal line connecting their tops.
4. Connect the top to the bottom on both sides, marking the edges of the receding plane.
5. Find the slanted plane VP by continuing the slanted edges back until they meet at a point either vertically above the eye level VP or vertically below it. If the height is at the back, it is an upward slant and its VP will be above. If the height is at the front, it is a downward slant and its VP will be below.
6. Draw one of each.

In figure 6–18 complete the drawings of wedges in one point perspective and find the vanishing points. Answers are at the end of the chapter.

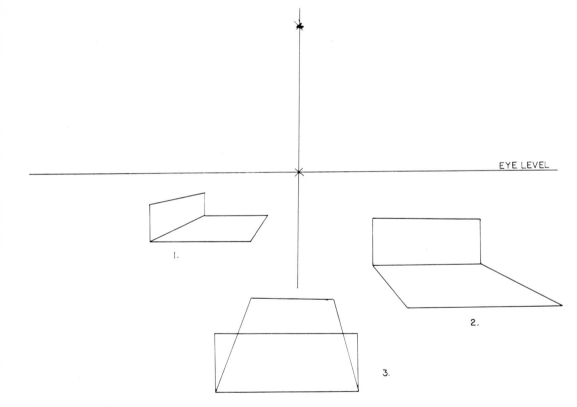

FIGURE 6–18

Stairs from Wedges

Slant Not Receding Many people have trouble drawing stairs, but it need not be a great problem. Most sets of stairs you will draw will occupy a highly visible and limited amount of space. When this is the case, the wedge can be used as a starting point. This has the advantage of allowing you to place the stairs exactly where you want them with no gap between the stairs and the wall, floor, or ground. To do this, place the bottom or flat surface of the wedge on the ground plane touching the wall. Think of the wedge as a ramp; a ramp with teeth (risers and treads) becomes a set of stairs. The riser is the vertical surface; the tread is the flat surface on which you step. The wedge should be the same proportions as a single step: a riser should be no more than 6 in. high, and a tread should be at least 9 in. deep. When a wedge is seen in a profile view, the slanted plane is not receding, so the wedge does not have a slanted plane vanishing point. Each step can be drawn the same height by dividing the vertical height of the wedge equally by measurement. Try it, using this list as a guide:

1. Draw the wedge with its slant not receding in one point perspective with the eye level above it. Remember, it should be the same proportions as a single step; therefore, the height should be no more than two-thirds of the length of the base.

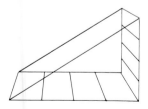

FIGURE 6—19

2. Divide the height into four equal risers and divide the base into four equal treads. Take these divisions toward the VP to the back profile. See figure 6—20.

FIGURE 6—20

3. On the far side, draw horizontals and verticals at the marked divisions. These will intersect beyond the wedge slant. See figure 6–21.

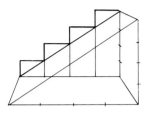

FIGURE 6–21

4. Repeat this procedure on the near side as in figure 6–22.

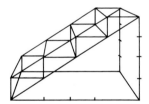

FIGURE 6–22

5. Connect tops and bases of each riser with a line toward the VP. See figure 6–23. The stairs are complete as in figure 6–24.

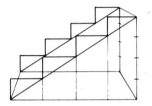

FIGURE 6–23

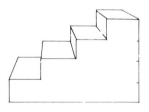

FIGURE 6–24

6. Check your accuracy by drawing a line through the top of each riser on both sides. These lines should be parallel to the wedge slants and to a line through the bottom of the risers. All these lines are drawn parallel to each other, since this slanted plane is not receding.

House and Stairs

Using methods just learned, draw the house with stairs in figure 6–25. Remember to draw the base of the stairs and the base of the house on the same line to avoid a gap between the two. The handrail should be parallel to the wedge slant and should be at least 3 ft above the step it serves. If this were today's construction, it

would more likely be 3½ ft above. The known dimensions of the steps will provide
the scale for the front of the house and the height of the handrail on the house.

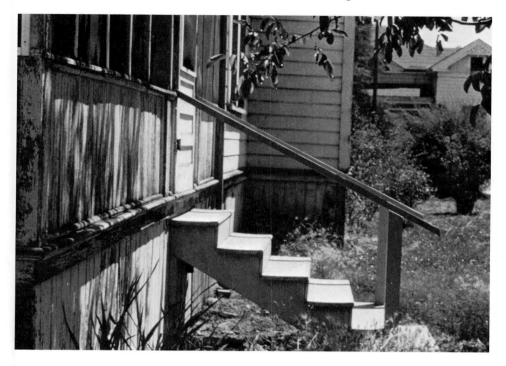

FIGURE 6—25

Slant Receding, One Point
Block of stairs

1. Start with a wedge in one point with the height at the back. Include eye-level
 VP and slanted plane VP.

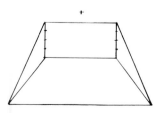

FIGURE 6—26

2. Divide the height equally by measurement into any number you wish. These are riser heights. The tread depth divisions cannot be marked in this view because the base is receding.

3. Next project riser divisions forward to the slanted line and beyond. These will become the treads.

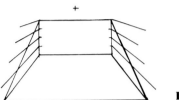

FIGURE 6—27

4. Starting at the front base of the wedge, draw a vertical on each side to meet the tread above.

5. Where this tread emerges from the wedge slant, draw the second riser on each side. Continue to the top. The profile on both sides is complete.

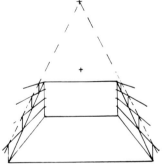

FIGURE 6—28

6. Connect the two profiles with a horizontal line through the bottom and top of each riser. The stairs are complete.

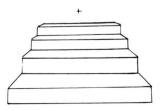

FIGURE 6—29

7. Check the accuracy of your drawing with a line through the top of each riser. It should go to the same slanted plane VP as a line through the bottom of each riser and the receding slant of the wedge.

Use of Vertical Measuring Line

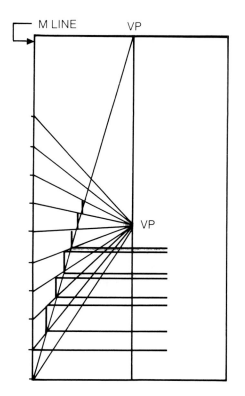

FIGURE 6–30

Figure 6–30 shows an alternate method for finding receding stair heights by using a vertical measuring line. On it are marked equal divisions based on the height of the first step. A horizontal line from each division recedes to the eye level VP. These become the treads where the slanted plane line crosses them.

Now draw the stairs and house in figure 6–31. Show the ground line of the house wall on both sides of the stairs.

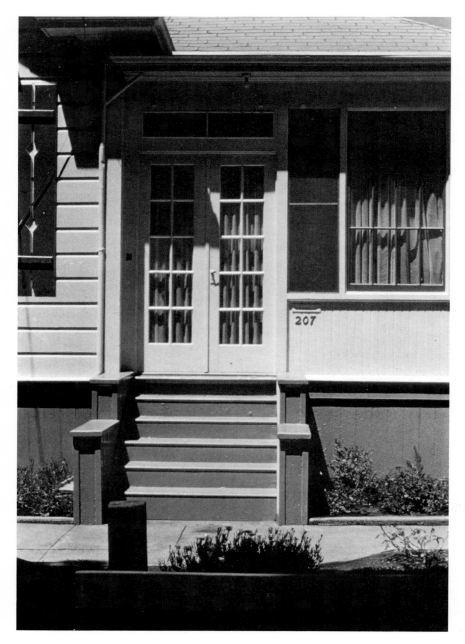

FIGURE 6–31

Slant Receding, Two Point Try the same thing with stairs in two-point perspective:

Block of Stairs

1. First, draw a wedge in two-point perspective with its height at the back; include its hidden edges. Locate all three VPs and eye level.
2. Divide the height by measurement on the closest side.
3. Take these division points back to the eye level VP through to the other side, dividing it equally too.

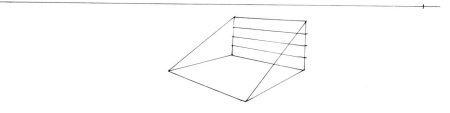

FIGURE 6—32

4. Project forward from eye level VP through divisions on both sides. Extend beyond the slants

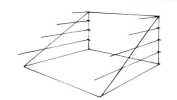

FIGURE 6—33

5. Connect with vertical risers as before, starting at the bottom of the wedge.

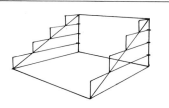

FIGURE 6—34

111

6. Connect edges of the treads across. They should go to the eye-level VP.
7. Check your accuracy by drawing lines through tops and bottoms of the risers on each side. All four lines should go to the slanted plane VP.

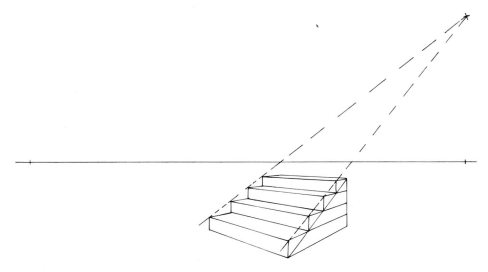

FIGURE 6—35

Use of Vertical Measuring Line

Figure 6–36 shows the use of a vertical measuring line to find heights of receding risers of stairs in two-point perspective.

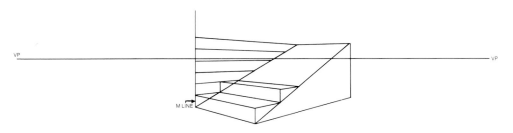

FIGURE 6—36

Stairs and House

Now draw from this photo, figure 6–37.

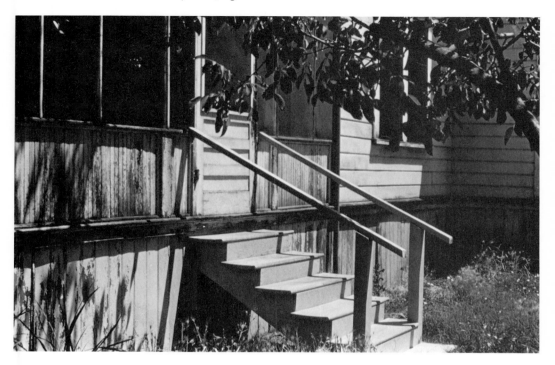

FIGURE 6–37

STAIRS IN UNLIMITED SPACE

Two Point

Sometimes it is inconvenient or impossible to draw the flat plane of a wedge underneath stairs, for example, when you are drawing steps in a garden not connected to a building, or steps going up the side of a hill, or a long flight of stairs where you can't see the top or bottom. Another method can be used to draw these stairs in unlimited space. It is not at all difficult if you think of each step as a box. Try this method in two point:

1. First, draw the eye level and two vanishing points far apart.

2. Now, below the eye level, draw a long box the shape of a step. This first step establishes the proportions—height, length, and depth.

FIGURE 6–38

3. The first step has also established the slant or steepness for the stairs. To find the slanted plane VP, draw a line at the end of the box from the bottom front to the top back and continue it to a point vertically above the eye level VP. Do the same on the opposite end; it will go to the same VP. All the risers will go vertically up from this line on either side.
4. Draw a line from the top front corner of each end of the box to the same slanted plane VP. The tops of all risers will end on these lines.

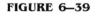

FIGURE 6–39

5. The second riser continues straight up from the back of the first box on both sides, stopping at the slant plane line.
6. Connect the tops of these riser ends. This line if extended would go to the eye level VP.

114

7. The second tread (or top of the second box) goes back to its eye level VP, stopping at the slant plane on each side.
8. Connect across. Two stairs are complete.

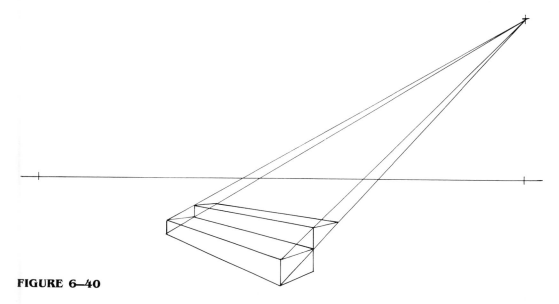

FIGURE 6—40

9. As you continue to build the stairs as far as you like, you will find that above the eye level, part of each riser is hidden by the step in front of it. It will be helpful to draw those hidden lines to locate each step properly.

FIGURE 6—41

115

Now draw this, figure 6–42.

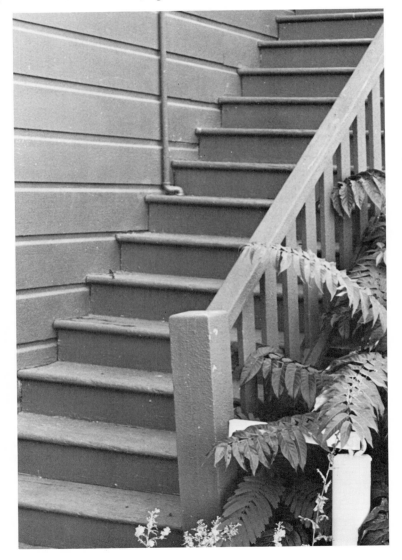

FIGURE 6—42

One Point

Now try this method for stairs in one point with no side showing.

1. Draw the eye level and centrally locate the vanishing point.
2. Next, draw a long box, which will be the first step, below the eye level.
3. Find the slanted plane VP.

FIGURE 6—43

4. Draw the slant plane lines to the VP, marking the bottom and the top of the risers on each side.

FIGURE 6—44

5. Now draw the second riser straight up between the two lines on each side. Connect across.

6. Draw the tread between the slanted lines to the level VP. Connect straight across to form the second step.

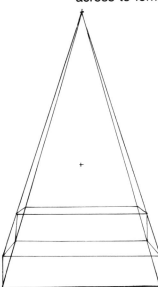

FIGURE 6—45

7. Continue as far as you like, taking the stairs above eye level. Hidden lines do not have to be drawn until you get above eye level.
8. For accuracy, check verticals, horizontals, and slant plane lines.

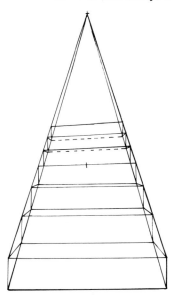

FIGURE 6—46

Now draw this, figure 6–47.

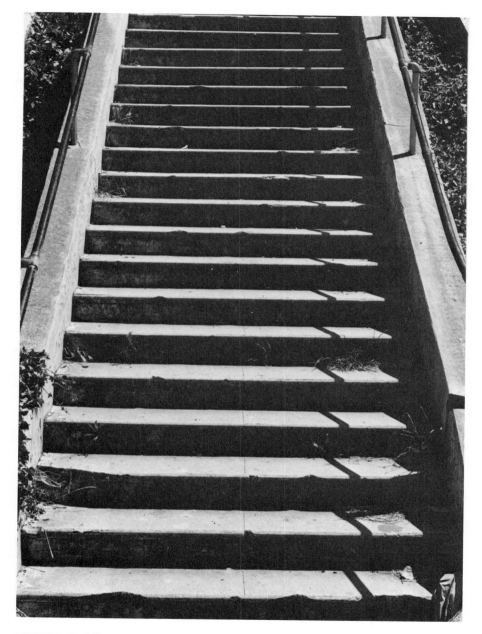

FIGURE 6–47

House with Stairs

You have worked with several ways to use the slanted plane and its vanishing point. Now combine some of these in a single drawing by drawing a simple rectangular house with a shed roof, and a few steps ending with a landing or porch at the front door. Put a handrail on the steps and the landing. The handrail follows the slant of the steps. You may choose to do your drawing in one point or two point. If you have any problems, refer to the step-by-step instructions. Try for reasonable proportions.

Here are two photos to draw from if you wish.

FIGURE 6–48

FIGURE 6—49

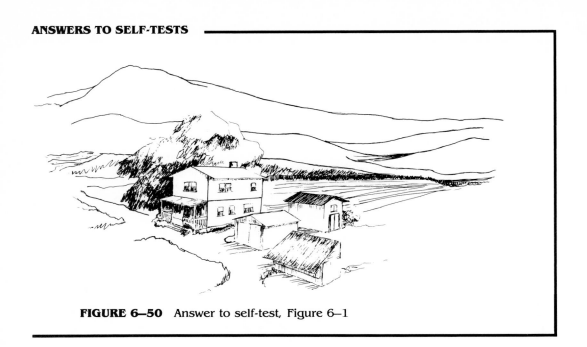

FIGURE 6—50 Answer to self-test, Figure 6—1

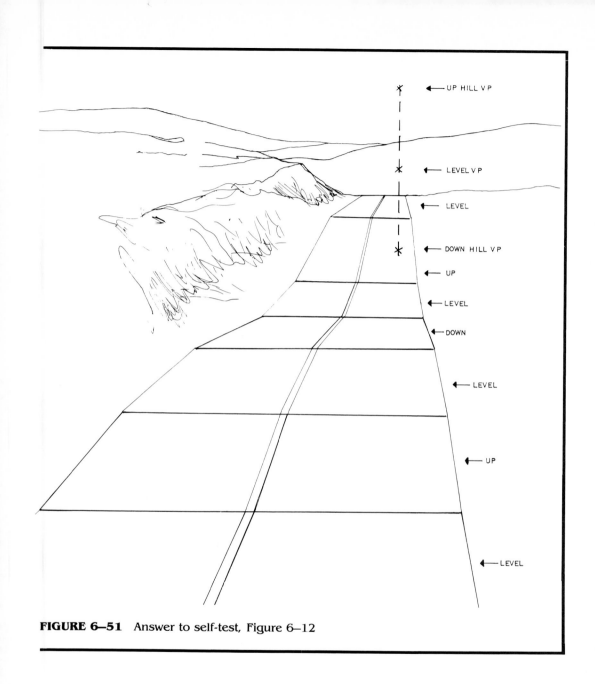

FIGURE 6–51 Answer to self-test, Figure 6–12

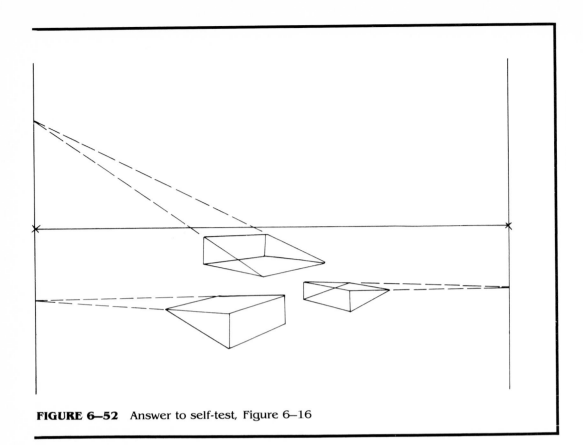

FIGURE 6—52 Answer to self-test, Figure 6—16

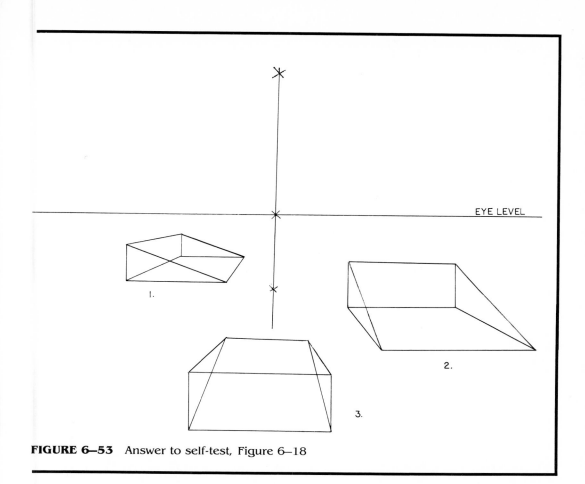

EYE LEVEL

1.

2.

3.

FIGURE 6—53 Answer to self-test, Figure 6—18

7

multiple
vanishing
points

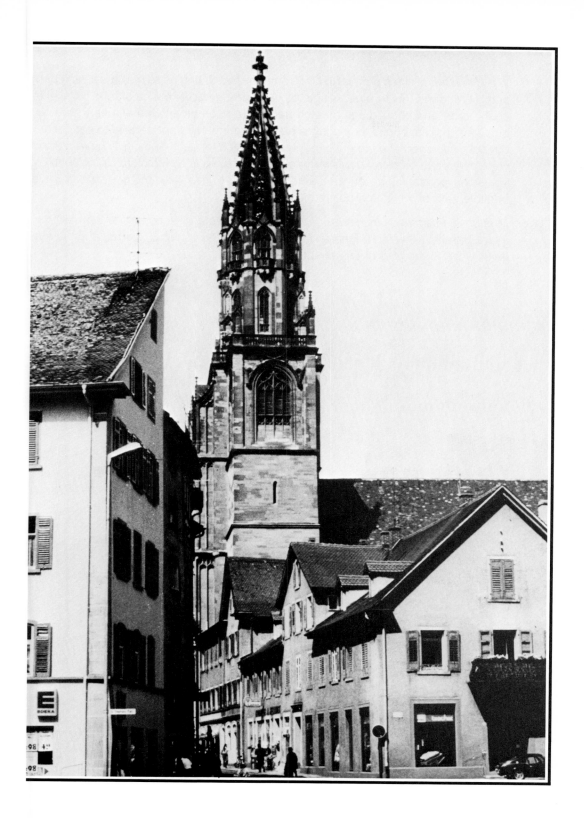

WHY MULTIPLE VANISHING POINTS

We know that all lines parallel to each other and receding go to the same vanishing point. We found this true of a single box and of a group of boxes placed parallel to each other, and of buildings erected parallel to each other. Sometimes, however, buildings, boxes, books, or pieces of paper on a table are *not parallel* to each other but are positioned at a variety of angles. In this case, each object will have its own vanishing point or set of vanishing points. If all objects are on a flat surface, their vanishing points will be on the same eye level. In this way it is possible to have multiple sets of vanishing points in a single view.

Multiple vanishing points are used to show multiple directions in a single view. Trace parallel receding edges on this photo. Find the vanishing points and the eye level. Turn to the end of this chapter for answers.

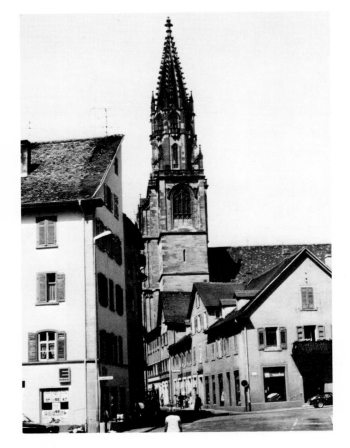

FIGURE 7–1

128

HORIZONTAL PLANES

Flat Road Changing Direction

Now use multiple vanishing points to draw a flat road that changes direction several times (fig. 7–2). When the direction changes, the vanishing point for each directional segment is repositioned along the eye level to the left or right. Lines dividing the segments will be horizontal because the road is flat. A curving road can be drawn as a series of straight segments with the angles smoothed out. To draw a road changing direction,

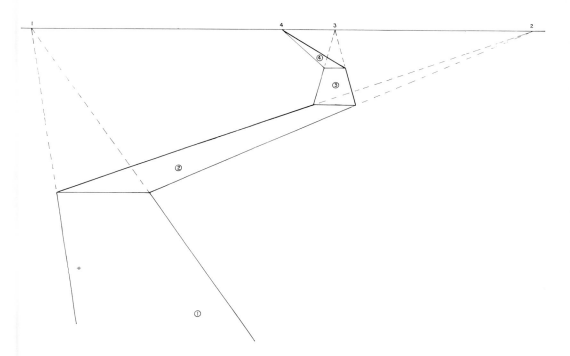

FIGURE 7–2

1. Establish the eye level.
2. Locate a VP anywhere you wish on the eye level.
3. Now near the bottom of your paper draw a section of road going to the VP. A horizontal line will end this section.
4. Next find another VP on the eye level.
5. From the back limits of the first section, go toward the second VP and stop at another horizontal line.

6. Add a third VP and a third section, then a fourth, changing the direction of the road each time.
7. For a more finished result, the horizontals can be erased and the angles curved if you wish.

Road Changing Direction and Elevation

Now suppose a road is going uphill or downhill as well as changing direction to the left and to the right. Each section going up or down is a slanted plane and will have its vanishing point vertically above or below the vanishing point it would have if it were flat. Figure 7–3 shows a road going up and down as well as to right and left. Find the eye level and find the vanishing point for each section. Label each section *up*, *down*, or *flat*. When you are finished, check it with the answer at the end of the chapter.

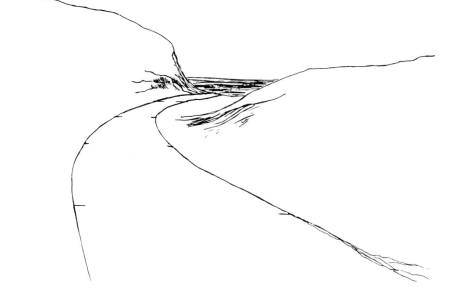

FIGURE 7–3

Now draw one of your own. Refer to figure 7–4 for procedure, yours will be different.

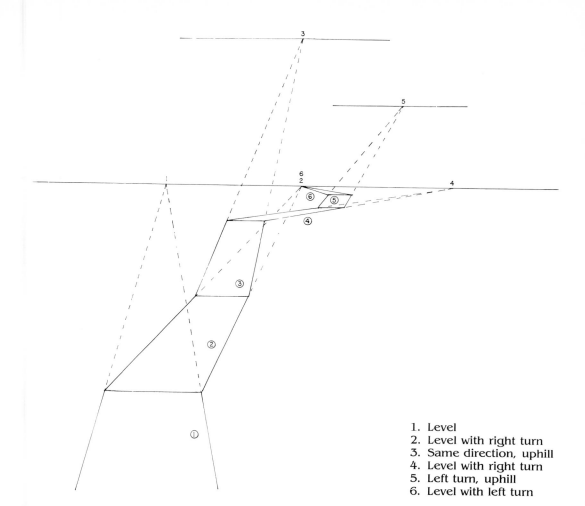

1. Level
2. Level with right turn
3. Same direction, uphill
4. Level with right turn
5. Left turn, uphill
6. Level with left turn

FIGURE 7—4

If you would like some extra practice using these principles, try drawing a receding road intersecting another road at a sharp angle, or draw two city streets intersecting at right angles, in one point or two point.

VERTICAL PLANES

Folding Screens

These principles can also be applied to vertical planes. Draw a folding screen standing at random angles. This is the procedure for figure 7–5.
First, establish the eye level with a vanishing point on it.

Panel 1 Draw a vertical line crossing the eye level, and receding lines from its top and bottom toward the VP. Stop at the next vertical, which forms the far edge of the first panel. All panels parallel to the first one will recede to this VP.

Panel 2 Now add a second VP on the eye level. If the second panel is to come forward, extend it forward from the second VP through the back of the first panel. Make it as wide as you wish.

Panel 3 This panel is not receding, so it has no VP. The top and bottom are parallel to the eye level.

Panel 4 This panel recedes to another VP.

Panel 5 This one comes forward parallel to the second panel.

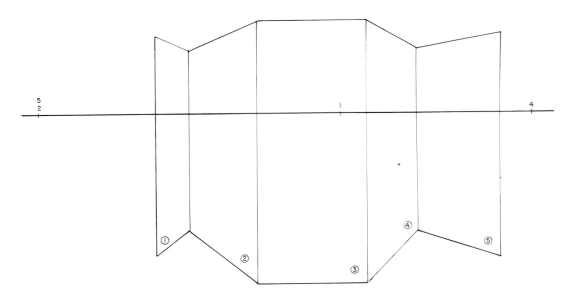

FIGURE 7–5

132

Now try drawing a screen of your own. Make this a seven-panel screen with panels of random widths standing at random angles. Show one panel not receding, and the next panel standing at a right angle to it.

THREE-DIMENSIONAL FORMS

So far we have been using multiple vanishing points only for surfaces, but the same principles apply as well to three-dimensional forms.

Stack of Books

Figure 7–6 is a stack of books in one point perspective. There is one vanishing point for the entire stack.

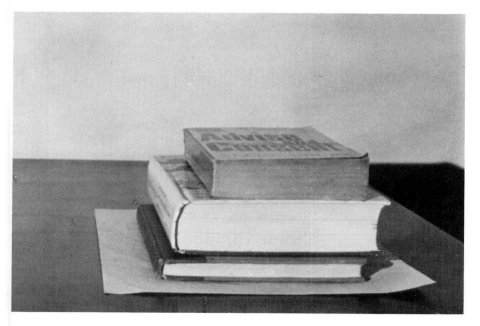

FIGURE 7—6

In figure 7–7 the books are stacked at different angles, each with its own set of two point vanishing points. Since they all are flat, all vanishing points are on the eye level. If you trace the several sets of vanishing points for this stack of books, you will find that each set is far apart, but not always the same distance apart. A *pivot point* is a convenient way to locate several sets of vanishing points such as these. The station point acts as a pivot.

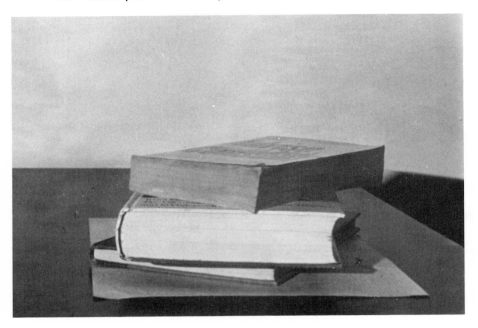

FIGURE 7–7

1. First establish the eye level.
2. Then draw the bottom book in one point with its VP.
3. Place the station point (SP) vertically below the VP, making this distance at least twice the distance intended for the drawing.

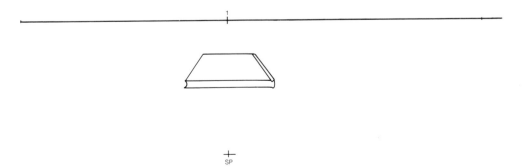

FIGURE 7–8

134

4. Place the square corner of a piece of paper or your triangle on the SP. Mark points where its edges cross the eye level, establishing a set of VPs for the second book.

5. Now rotate the square corner around its pivot, which is the SP, to locate a set of VPs for the third book.

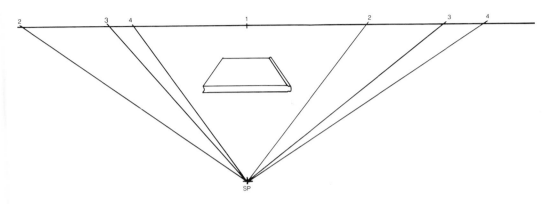

FIGURE 7—9

6. Do the same for a fourth book. Then draw the books from the bottom of the stack to the top. Number the VPs and the books correspondingly (fig. 7—10).

FIGURE 7—10

Spiral Stairway

If you want more practice with this idea, you might think of all these books as the same size and thickness and placed at the same angle of rotation around a vertical center line. You would then have the basis for a spiral stairway. However, treads of spiral steps are triangular rather than rectangular, so instead of a slant plane line, a center vertical is used to measure heights of risers.

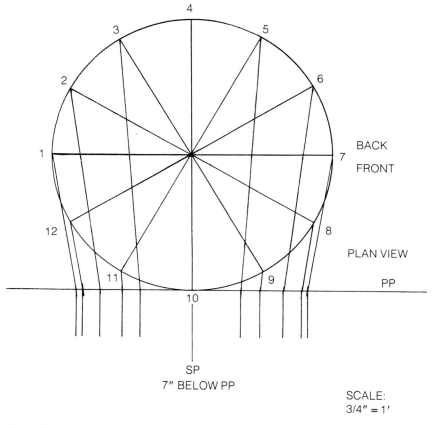

BACK
FRONT

PLAN VIEW

PP

SP
7″ BELOW PP

SCALE:
3/4″ = 1′

FIGURE 7–11

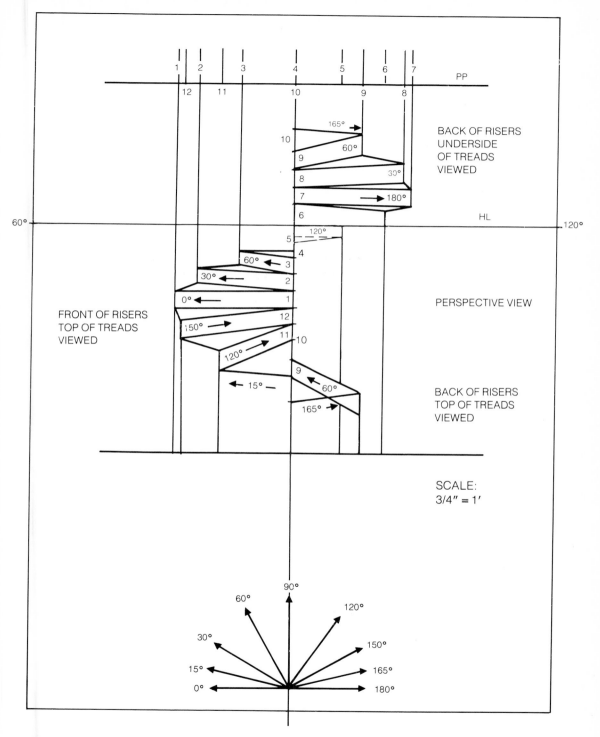

FIGURE 7-12

137

1. Start by drawing the vertical center line around which the steps will spiral. Extend it well above and below the area intended for the drawing. The SP and the plan view circle center will be on this line. See Figure 7–12.

2. Draw the HL and PP. Mark the SP.

3. Draw the plan view circle (fig. 7–11) and divide it into equal segments by placing a protractor at the circle center and marking the degrees. Figure 7–12 shows a 30-degree angle of rotation, so every 30 degrees is marked: 0, 30, 60, 90, 120, 150, 180. From each mark a line goes through the circle center and across to the opposite side.

4. From the end of each division on the circle draw a line toward the SP stopping at the PP, then vertically down to limit the length of each riser. It may be helpful to number them.

5. The step length is half the circle width at the PP. Here, it is the riser marked "1" shown as a horizontal. Divide this length by 5 or more for the riser height. Mark the center vertical with equal segments for the riser heights.

6. Use the protractor centered on the SP to establish VPs. If you have chosen a 30-degree angle of rotation, as in figures 7–11 and 7–12, mark VPs on the HL every 30 degrees for the risers: 30, 60, 90, 120, 150. Mark tread VPs at half rotation positions 30 degrees apart: 15, 45, 75, 105, 135, 165. If you use the plan view as shown in Figure 7–11, and if no riser is on a vertical or horizontal, you will not need tread VPs for construction, only to verify accuracy.

7. You will find it easiest to draw the risers first, then connect them with treads. Draw the first riser. The second riser goes to the 30-degree VP; the third goes to the 60-degree VP. Draw the connecting treads.

8. The fourth riser is seen only as an edge or vertical line. Its depth is shown by the treads above and below it. Draw the tread to a VP placed by adding half the number of degrees in the rotation to the *inside* of the turn; here 15 degrees, using the 165-degree VP. Riser 5 goes to the 120-degree VP, and the tread between 4 and 5 goes to the 15-degree VP.

9. Continue up or down as far as you wish, keeping within a 60-degree circle of vision established by the SP.

10. Label your drawing with the scale used. Take it from the riser height at the center.

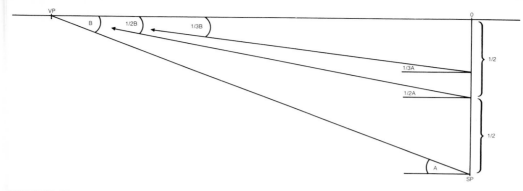

FIGURE 7–13

Vanishing Point Shortcut To prevent inconveniently extended paper and extremely long measuring tools, here is a shortcut that gives reasonable accuracy. It is particularly useful for placing and using VPs for angles of less than 30 degrees from a horizontal.

Instead of placing the VP, work from the vertical between the station point and the center of vision at *O* (*SPO*). The length of this line is proportionate to the angle at an established VP. Figure 7–13 shows how this is possible.

1. The placement of a VP is determined by the length of the *SPO* and the angle measured from the horizontal at SP, angle *A*.
2. Angle *A* equals angle *B*.
3. The length of *SPO* is proportionate to the VP angle, angle *B*.
4. If a receding line goes to the VP from the midpoint of *SPO*, its angle from the horizontal will be half the degrees of angle *B* at the VP.

To avoid unwanted distortion, the lower half of SPO is not used as part of the drawing, as it is not within the circle of vision for a 60-degree angle of vision. However, the entire length of the line *SPO* is used to determine the proportionate angle size of a receding line to a given VP.

Consider these examples:

If you wish to draw a receding line to a 15-degree VP, and that line starts at the halfway point on SPO, use one-half the number of degrees there are in the target VP, or 7½ degrees between your receding line and a horizontal drawn from the same point.

If your starting point is one-third of the total length of the SPO, measured from O, the degrees should be one-third, or five.

Twenty degrees or less may be used below two-fifths of SPO; over 20 degrees should be used only above two-fifths.

Alley

Using multiple vanishing points, draw from the photo in Figure 7–14.

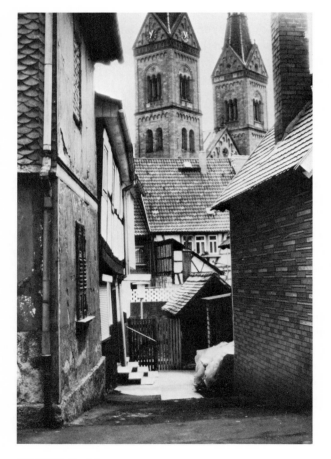

FIGURE 7–14

140

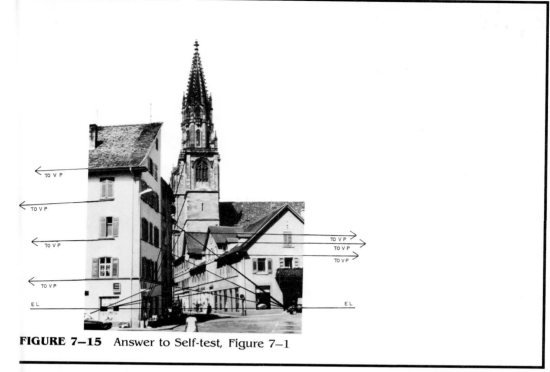

FIGURE 7—15 Answer to Self-test, Figure 7—1

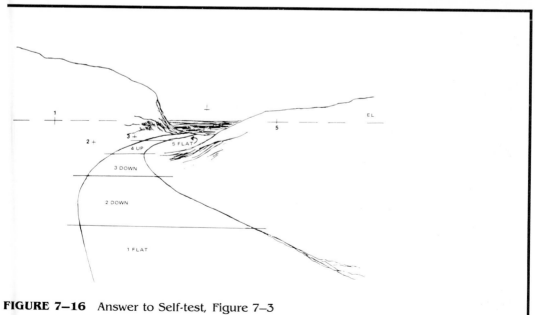

FIGURE 7—16 Answer to Self-test, Figure 7—3

8

the
circle

The sphere, ellipse, cylinder, cone, and dome are all shapes which have the circle in common and, therefore, share some concepts and terms. This chapter will define these terms and will show you how to draw these shapes and place them in space.

THE CIRCLE

A *circle* is a closed curved line, every point of which is the same distance from the center. The circle is divided into 360 equal parts called *degrees*. These are measured with straight lines called *radii* drawn from the center to the outside edge. One such line is called a radius. The distance between two radii is measured at the center. It is an angle that expresses a proportion of the whole circle. The exact number of degrees in any angle may be measured with a *protractor*.

A *sphere* is three-dimensional circle and is seen and drawn as a circle from any view.

Drawing a Circle

The usual tool used *to draw a circle* is a *compass*. It consists of two legs joined at one end, and includes a device for holding the legs apart at a selected distance. One leg is placed on a point while the other marks a line around it. This is the edge of the circle, called the *circumference*. The shortest distance between the center and the circumference is called a *radius*, and the distance across the center of the circle is a *diameter*. The diameter is a straight line the length of two radii; it is the circle size: "a 2-in. circle" is a circle with a 2-in. diameter. If a compass isn't available for drawing a circle, a pin and firmly held string will substitute; or for a very large circle, use a peg and rope.

Another way to draw a circle is with a circle *template*. A template is a pattern. A circle template is a piece of plastic with holes cut in it which are precise circles of several sizes. To use it, trace the desired circle size. Hold the template firmly and your pencil in a vertical position. The template is probably the easiest tool to use, but has the disadvantage of limiting size options to those on the template.

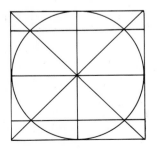

FIGURE 8–1

Still another way is to draw a circle within a square, as in figure 8–1. First, draw the square, making sure all its corners are right angles and all its sides are exactly the same length. Divide each side in half by measurement and connect across. Now draw two diagonals, one from each corner to its opposite. All these division lines cross at the center point. Next, measure from the center point to the center of a side. Repeat this measurement from the center point on each diagonal. Draw the circle freehand touching the center of each side and the mark on each diagonal. Keep the line going at a constant curve. Some practice with this will help you develop the ability to draw a circle freehand without a square to draw it in.

Placing a Circle

To place a circle accurately, place its center first, then draw the circle. A circle template has four marks on its circumference. If these are connected to their opposite sides they will cross, locating the center point.

Concentric Circles

FIGURE 8–2

Concentric circles are circles of different sizes with the same center, and on the same plane. These are often seen as concentric ellipses.

THE ELLIPSE

A circle seen in perspective, or foreshortened, is seen as an ellipse. An ellipse is a symmetrical figure which appears to be an elongated circle. Every part of its edge is curved; its ends are never pointed. In figure 8–3 label each circle with a "C" and each ellipse with an "E." Answers are at the end of the chapter.

145

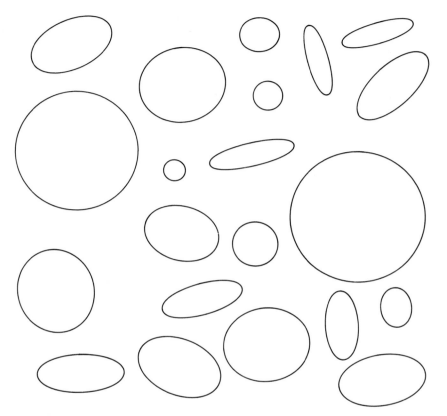

FIGURE 8–3

An ellipse has two axes, a *major axis* and a *minor axis*. They bisect each other (divide each other in half) and are perependicular. The major axis is the longest distance across the ellipse. In figure 8–3 draw the axes of each ellipse.

CHECKLIST

Check to be sure that
1. The major and minor axes of each ellipse divide each other exactly in half.
2. The major and minor axes of each ellipse are perpendicular.

Answers are at the end of the chapter.

Degree and Position

When describing an ellipse, the size and degree are given. The size is the measured length of the major axis. The degree is the proportionate difference between the lengths of the two axes. Commonly used ellipses range between a 15-degree ellipse, which is quite flat, and a 60-degree ellipse, which is quite round. The rotation from a full circle to a straight line is done with a turn of 90 degrees. See figure 8–4.

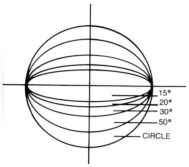

FIGURE 8–4

The ellipse starts as a circle parallel to the picture plane. Both axes are diameters and, therefore, equal. As the circle rotates around an axis, this axis becomes the major axis, seen full measurement, while the minor axis is shorter because it is seen in a foreshortened view. The degree of rotation is the degree of the ellipse. To measure it,

1. Draw an ellipse.
2. At each end of the minor axis, draw lines parallel to the major axis.
3. Between these lines draw the length of the major axis touching both parallel lines.
4. Measure the smaller angle formed at the point of contact. This is the ellipse degree.

Figure 8–5 is an example.

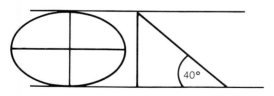

FIGURE 8–5

When a circle is seen perpendicular to the picture plane, its foreshortening or ellipse degree represents its diameter seen in a receding view.

Eye Level and Center of Vision Let's take a look at some ellipses. Here is a coffee mug with a round top and bottom and straight sides. Looking directly into the mug you can see that its top rim and its bottom rim are circles.

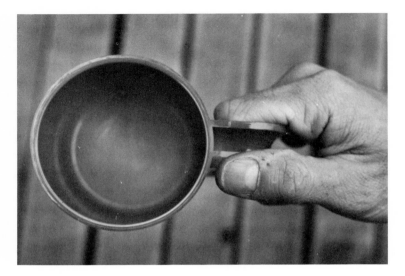

FIGURE 8—6

Put it on the table. The top is now seen as a horizontal ellipse. The bottom is also an ellipse, but you see only the front half of it.

FIGURE 8—7

As you lift the mug slowly, the ellipse top appears narrower and narrower until it appears as a straight line on your eye level. If you continue to raise it above eye level (EL), it appears rounder again.

148

At eye level a horizontal ellipse appears as a straight line; the farther it is above or below the eye level, the rounder it appears.

Now turn the mug on its side with its sides parallel to the picture plane and place it far to the right. The top is seen as a vertical ellipse. Now slowly move the mug horizontally across the table and you will see that the ellipse narrows increasingly until it appears as a straight vertical line directly in front of you, where it would cross your center of vision. Continuing past this point it appears increasingly round again.

FIGURE 8–8

At eye level (EL) or center of vision (CV) or on an extension of either, an ellipse perpendicular to the picture plane appears as a straight line. When a horizontal ellipse is moved parallel to the picture plane above or below the EL, the farther it is placed from the EL, the rounder it will appear. The same degree of roundness appears and increases when a vertical ellipse is moved to the right or the left of the CV or its extension. Find the EL and VP in figure 8–9. Answers are at the end of the chapter.

FIGURE 8–9

Degree and Angle of Vision When the major axis is horizontal and the minor axis represents a flat receding surface, the ellipse indicates an angle of vision by showing the depth of a square on a flat receding plane. When this is the case, and you want to draw within a 60-degree angle of vision, draw the minor axis no more than half the length of the major axis, yielding a 30 degree angle. To place the station point for the selected size of the ellipse, draw the square.

Drawing an Ellipse

To draw an ellipse always start with the axes, then there are several methods you may use: freehand drawing, an ellipse template, pins and string, or the foreshortened square. Choose the method that best suits your needs for accuracy and time spent. Practice all these methods so that they will be available to you when needed.

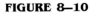

1. *Freehand drawing* of an ellipse with any degree of accuracy takes considerable practice. Use of the template will help here. It trains not only your eye but your muscle memory for the symmetry of the curve.
2. To use the *ellipse template*, match the center marks on the outside of the hole with your drawn axes. Hold the template firmly and hold your pencil vertically.
3. If you don't have a template or if the size you want is larger than template size, use the *pin and string method*:
 a. Place pins at the ends of the major axis and tie a loop of thread snugly around them.
 b. Mark thread at the minor axis cross point (center) and remove the loops from the pins.
 c. Place the marked center at the outside end of the minor axis.
 d. With the string taut, find the points where the loop ends touch the major axis, and reposition the pins at these points with the loop around them.
 e. Hold your pencil vertically inside both strands of loop and draw a half ellipse, keeping the string taut. Then lift your pencil and complete the ellipse.

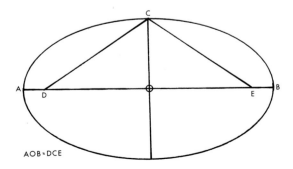

FIGURE 8–10

150

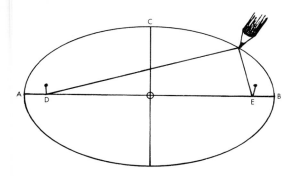

FIGURE 8–11

To draw a *freehand ellipse within a foreshortened square*, first draw the square:

1. Draw a horizontal that will be the center of the square.
2. Draw EL, VP, and SP on the EL. Place VP vertically above center of the horizontal drawn. Place the SP on El at least twice as far from the VP as the intended limits of the drawing.
3. Draw lines from the VP through and beyond the center and both ends of the horizontal.
4. Draw a line from the SP through the horizontal center and beyond to intersect receding lines on both sides.
5. Draw horizontals at intersection points on each side. This is a square in perspective within a 60-degree angle of vision. Draw its other diagonal.

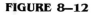
THIS DISTANCE IS SLIGHTLY LESS THAN
1/6 OF THE WIDTH OF THE WHOLE CUBE

FIGURE 8–12

151

Then draw the ellipse:

1. Measure the vertical center line of the square and divide it in half. This will be the center of the ellipse. Draw a horizontal here for the major axis.
2. Extend the vertical minor axis below the square and measure on it half the length of the closest horizontal. In figure 8–12, $AB = AC$.
3. Draw the line BC and place D on it so that $CD = AB$.
4. From D draw a vertical line to the closest horizontal of the square, then back to the VP. At intersection points with diagonals draw horizontals to intersect diagonals on the opposite side.
5. Draw the ellipse through these four points and through the ends of the ellipse axes. Keep the ellipse curved with no flat or pointed places.

The Circle Center

If your ellipse represents a foreshortened circle, you may need to locate the center to place the hands of a clock, spokes of a wheel, or the center of a radial pattern of a rug. To do so, draw crossing diagonals. You will find that the circle center is slightly behind the ellipse center on the minor axis. This is because the back half of the circle appears smaller than the front half. A symmetrical ellipse fits the same circumference because the front half of the circle not only appears deeper than the back half, but wider as well. Draw the circle; then locate its center and the ellipse center. Label both.

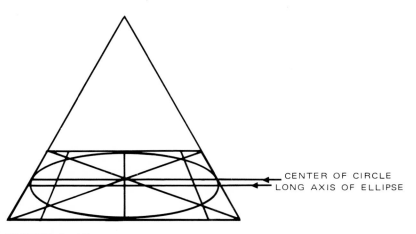

CENTER OF CIRCLE
LONG AXIS OF ELLIPSE

FIGURE 8–13

Placing an Ellipse

To place an ellipse, locate the center; then locate the axes, keeping in mind that the minor axis is a foreshortened view of the major axis.

Concentric Ellipses

Concentric circles are circles which have the same center. They are on the same plane, but are different sizes. When they are on a receding plane they are seen as ellipses. To draw them,

1. Draw a receding square centered below the CV.
2. Draw diagonals to opposite corners locating the circle center. This circle center will be the center for all circles concentric to the first one.
3. Draw an ellipse in the square. It is your first circle seen in perspective.
4. For each additional concentric circle, draw a horizontal through the same circle center for constructing a smaller square within which is drawn an ellipse of the same degree.

Stacked Ellipses

Stacked circles seen as ellipses do not have a common center. Their centers are often on the same straight line. They may be the same size or different sizes, and the spaces between them often vary widely. If they are quite close together their degrees may be the same, or the degrees may change, becoming smaller as they approach the EL or CV.

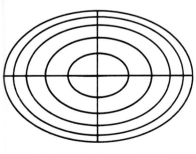

CONCENTRIC ELLIPSES

FIGURE 8–14

STACKED ELLIPSES

FIGURE 8–15

153

Draw a wheel with an axle from one of the two photos, figure 8–16 or figure 8–17. The axle lies on the minor axis of the large ellipse, and it goes through the circle center in back of the ellipse center.

The ellipse in nature is often somewhat irregular, but the same principles apply. Draw from one of the following two photographs, figure 8–18 or figure 8–19.

FIGURE 8–16

FIGURE 8–17

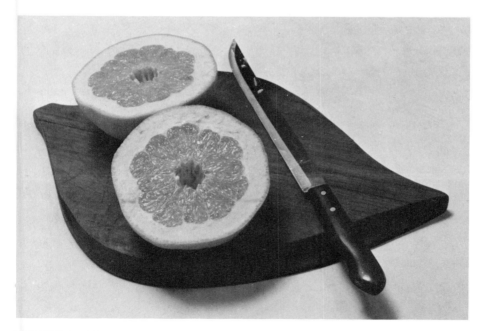

FIGURE 8–18

FIGURE 8–19

THE CYLINDER

The cylinder is a tube of constant diameter. Its ends are circles perpendicular to the center length of the tube and are usually seen as ellipses.

Drawing the Cylinder

To draw the cylinder, first draw its center length, and then the ellipses at both ends. The minor axes of the end ellipses lie on the center length line of the cylinder, no matter what its position. Figure 8–20 shows some cylinders with ellipses for ends. Draw the center length line of the cylinders and the major and minor axes of ellipses at each end. Answers are at the end of the chapter.

FIGURE 8–20

Placing the Cylinder

When drawing cylinders on a flat surface, it is important, first, to place them by establishing the surface occupied by each. A cylinder on end occupies the space covered by its base ellipse, but a cylinder on its side overhangs the surface under the width of the cylinder. It touches on one line only vertically below the center core. Verticals drawn from the outside edges of the ellipse ends will help you to estimate the overhang, but it may be necessary to draw a square-ended box around the cylinder to avoid equivocal space.

Drawing Cans Draw the cans in figure 8–9.

CHECKLIST

Check your drawing to make sure that
1. Each ellipse major axis is perpendicular to its minor axis.
2. Each ellipse minor axis lies on the center length of the cylinder.
3. No two cylinders occupy the same space.

Cylinders in Architecture Figures 8–21 and 8–22 are photos of the cylinder used in architecture. Choose one of the photos and draw it. Use the same procedure and checklist as in the last drawing.

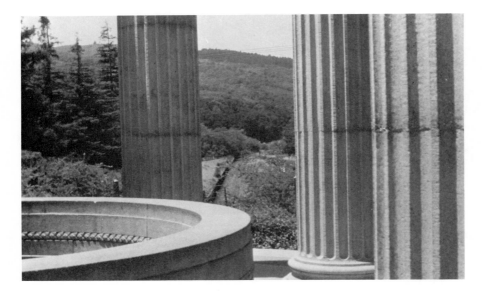

FIGURE 8–21

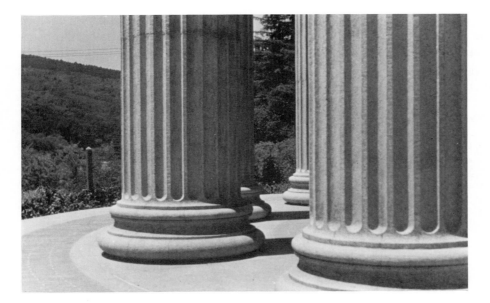

FIGURE 8–22

158

Cylinder Changing Direction When a cylinder changes its direction, the new direction can be shown by the overlapping profile of the section closest to you.

Pipes, cylindrical air ducts, and limbs of trees often make turns in direction. When these turns are seen in profile (not receding), the outline explains the change in direction. To expalin whether a new direction recedes or advances, draw the overlapping profile of the section closest to you. This method is very helpful in drawing natural cylindrical forms, which, though irregular, follow the same basic rules. Shading is another help in showing the form by using lines that go around the cylinder and follow the curve of its elliptical cross section.

FIGURE 8–23

The drawings of a tree in figure 8–23 show outline only, overlapping, and directional shading. Chapter 9 deals more completely with shading and cast shadows.

Cylinders in Nature Figures 8–24 and 8–25 are photos of cylinders in nature. Because they are organic they are somewhat irregular, but they follow the same principles as geometric forms. Choose one of these photos and draw it.

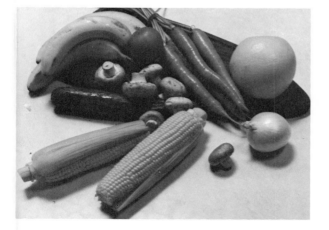

FIGURE 8–24

FIGURE 8–25

The Cylinder Used for Construction

Open Book The cylinder and its ellipse ends can provide a guide for the pages of an open book. Figure 8–26 shows a book in two-point perspective. The corners of the pages form a half circle, seen here as a half ellipse. The far ellipse is the same

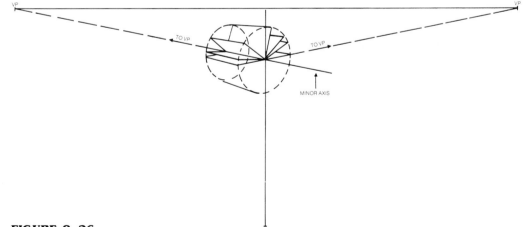

FIGURE 8–26

degree as the closer one, but is a smaller size. This procedure may also be used for wheels on an axle when the wheels are perpendicular to the axle.

Open Door An open door is similar in form to an open book, except that the cylinder is vertical and the ellipse is horizontal. See figure 8–27. The base of the

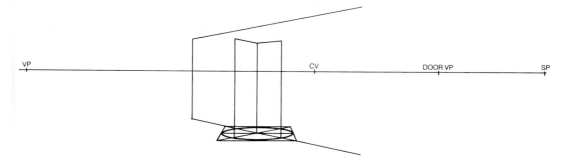

FIGURE 8–27

hinged edge of the door becomes the center of a foreshortened circle, seen as an ellipse. The door will swing through half of this ellipse. To draw it,

1. Choose a door width and find its equivalent by measurement on the hinged vertical.
2. Draw this length as a horizontal from the base of the hinged vertical. Repeat the same measurement, continuing the horizontal on the opposite side. This completes the horizontal center of a foreshortened square within which the ellipse will be drawn.
3. Use a VP centered above the horizontal with the SP to complete the fore-shortened square.
4. Draw the ellipse within it.

The door jamb at the open side of the door is drawn vertically from the point where the ellipse crosses the base of the wall. The open door is drawn at any chosen angle from the circle center to any point on the ellipse. Follow this line back to the EL and mark a VP which is used for the receding top of the door. A vertical from the bottom to the top completes the open door.

THE CONE

The cone is a tapered cylinder. Its point is on the center core line. In this drawing of cones and partial cones, find the ellipses and draw the major and minor axes of each. Draw the center core line of each conical form and locate the cone point for each. Answers are at the end of the chapter.

FIGURE 8—28

Drawing the Cone

To draw the cone, start with the center length. The circle end is usually seen as an ellipse. As with the cylinder, place the minor axis on a continuation of the center length.

Here is a photo of some conical shapes. Draw from the photo. To check your accuracy, use the checklist for cylinders and make sure the cone point is on the center core line of the cylinder.

FIGURE 8–29

THE DOME

A dome is a half sphere, though many domelike shapes are shallower or deeper than half spheres. *To draw a dome, find the ellipse of the base and the center point of the rounded top, located on an extension of the minor axis of the ellipse.*

To locate the top of a dome,

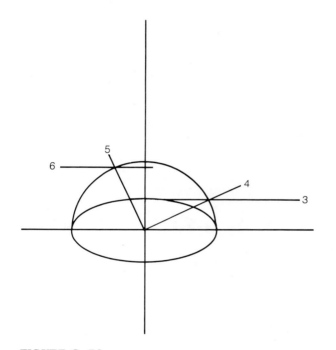

FIGURE 8–30

1. Draw the dome as a half circle.
2. Draw the ellipse on the same axis.
3. Add a tangent to the ellipse parallel to its major axis through the top of the minor axis and through the dome edge. (A tangent is a straight line touching a curved line at one point only.)
4. Draw a line from this intersection to the center.
5. Draw another line from the center at a right angle to line 4 through the dome.
6. From this intersection point, draw a line parallel to the ellipse major axis extending through the dome height.
7. The point where this line crosses the dome height is the top of the dome.

Here are some drawings of domes and domelike shapes. For each dome draw the ellipse and its long and short axes. Put a small X at the top point of each dome. Answers are at the end of the chapter.

FIGURE 8—31

Drawing the Dome

To draw the dome, draw its ellipse first; then draw its height on an extension of the ellipse minor axis. Next, locate its top.

Figure 8–32 was taken standing on the ground with the camera face (picture plane) tilted up at the domes, giving the effect of three-point perspective. Draw it in one-point perspective if you want to, placing EL at the bottom of the drawing.

FIGURE 8–32

To draw the domes,

1. Locate the camera's eye (eye level).
2. Position each dome by drawing its ellipse and axes.
3. Extend the minor axis to the height of the dome (center point).
4. Connect the curving edges from the ellipse to the center point.

Dividing a Dome

A dome can be divided into equal segments by projection from a nonreceding

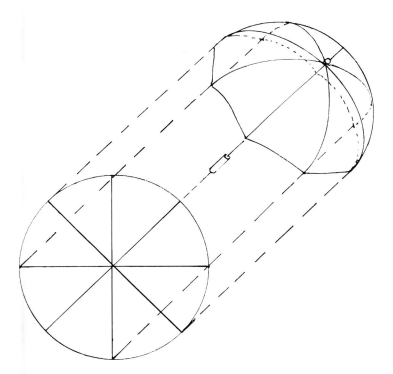

FIGURE 8–33

Try this by drawing an umbrella (fig. 8–33):

1. Draw the ellipse, which is the open edge of the umbrella. The continuation of the minor axis will be the handle.
2. Continue the minor axis on the other side to make the dome as flat or as deep as you wish.
3. Extend the handle line (center core) downward and draw lines parallel to it from each end of the ellipse.

167

4. Draw a nonreceding circle within these lines.
5. Divide the circle into as many parts as you wish (here, eight). These become the ribs of the umbrella seen as a plan view.
6. Take these division points back to the ellipse, then over the dome to the center.

Using this method to project from a circle to an ellipse you can locate evenly spaced divisions on ellipses such as clock faces, spokes in a wheel, flutings on a column, or edgings on a plate. It can also be used for irregular spacings sometimes found on round rugs, lettering on round signs, or emblems.

Figure 8–34 shows some familiar domes and cones. Draw them.

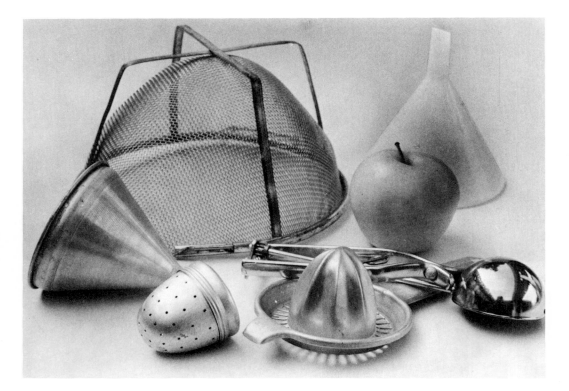

FIGURE 8–34

SELF-TEST *(Answers are below)*

In the margin before each term in the left-hand column, place the letter for its definition selected from the right-hand column.

1.	circle	A.	shortest distance across center
2.	sphere		
3.	compass	B.	ellipse measurement
4.	circumference	C.	divide in half
5.	radius	D.	a tapered cylinder
6.	diameter	E.	having the same center
7.	template	F.	tool for drawing a circle
8.	ellipse	G.	symmetrical elongated circle
9.	major axis	H.	part of a sphere
10.	minor axis	I.	three-dimensional circle
11.	axes	J.	distance across a circle
12.	degree	K.	distance around a circle
13.	cylinder	L.	a tube, usually straight
14.	cone	M.	in receding perspective
15.	dome	N.	more than one axis
16.	tangent	O.	greatest distance across
17.	bisect	P.	pattern for tracing
18.	foreshorten	Q.	from center to edge
19.	concentric	R.	a symmetrical curved flat shape
		S.	touching at one point

Answers: 1. R; 2. I; 3. F; 4. K; 5. Q; 6. J; 7. P; 8. G; 9. O; 10. A; 11. N; 12. B; 13. L; 14. D; 15. H; 16. S; 17. C; 18. M; 19. E.

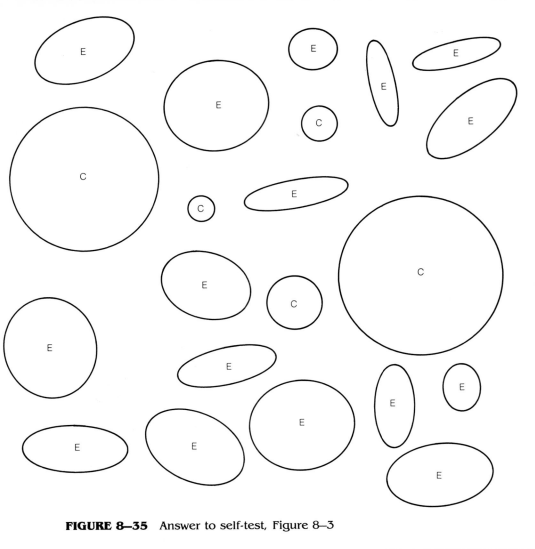

FIGURE 8–35 Answer to self-test, Figure 8–3

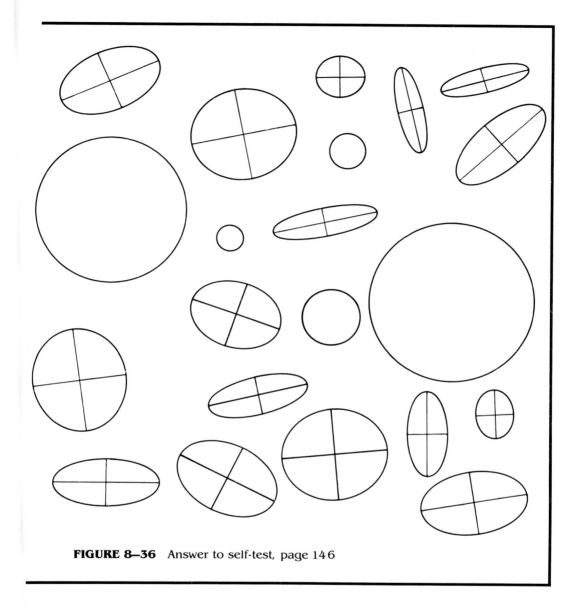

FIGURE 8–36 Answer to self-test, page 146

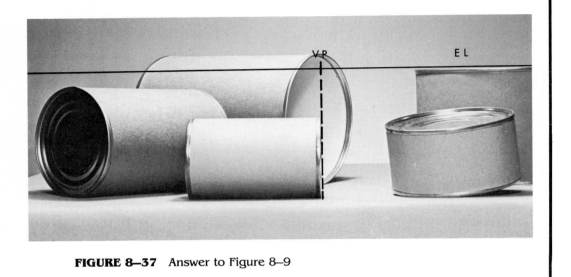

FIGURE 8–37 Answer to Figure 8–9

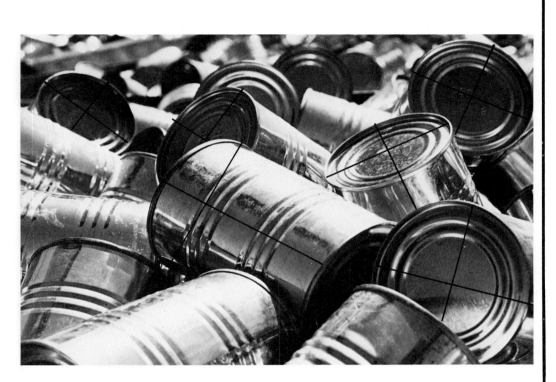

FIGURE 8–38 Answer to self-test, Figure 8–20

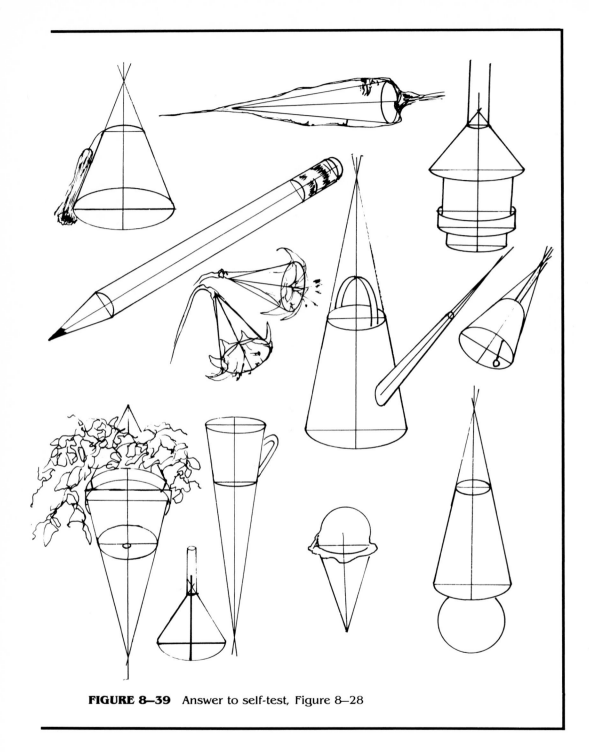

FIGURE 8–39 Answer to self-test, Figure 8–28

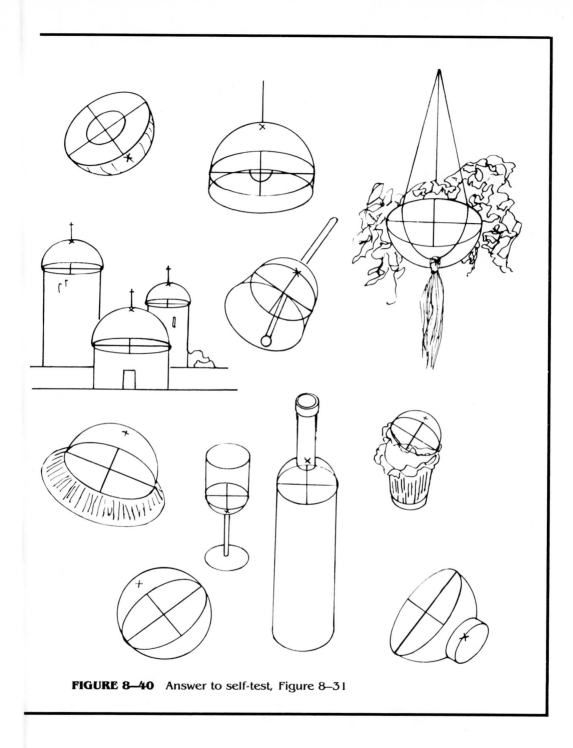

FIGURE 8–40 Answer to self-test, Figure 8–31

9

shading and cast shadows

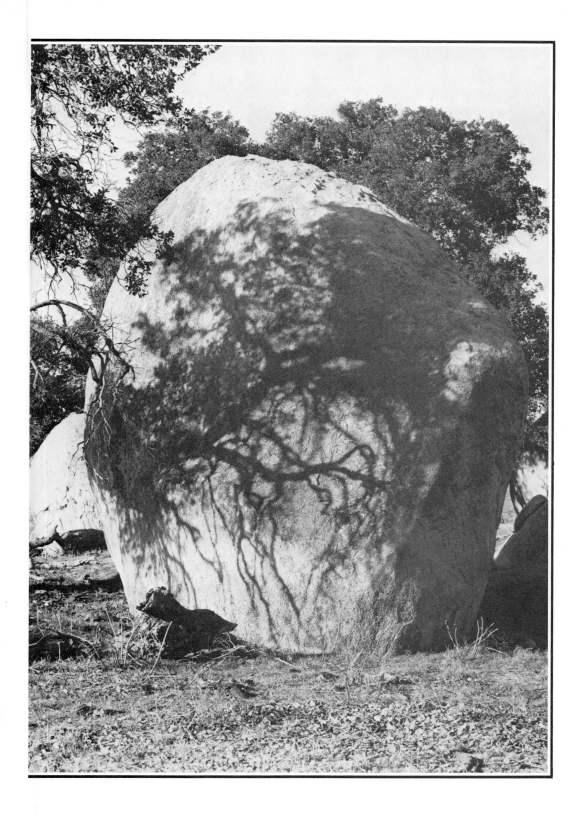

EXPRESSIVE PURPOSES

Shading and cast shadows are very useful in drawing and painting; they can create a pattern of dark shapes to strengthen a composition, set a mood, or suggest a time of day or season of the year (fig. 9–1).

FIGURE 9–1

They can also clarify three-dimensional expression by describing the forms that cast shadows and by describing the direction and texture of the surface on which the shadow falls (fig. 9–2).

FIGURE 9–2

SOME GENERAL CONSIDERATIONS

Clarity of Shadow Edges

Some shadows are vague and diffused almost to the point of being nonexistent. This is observed on an overcast or foggy day, or when light is coming through a frosted window or from an electric light designed to minimize shadows. Such shadows are sharp only where the form contacts the surface. On a bright clear day, when shadows are most clearly defined, the decreasing clarity along a shadow edge is directly related to the distance between the form casting the shadow and the surface on which the shadow is cast. The closer these are, the clearer the shadow edge; as the distance increases, the shadow becomes fuzzier (fig. 9–3).

FIGURE 9—3

Darkness of Shadow

Generally, a bright light produces a dark shadow, but other factors sometimes modify it. Multiple light sources produce multiple shadows that can partially cancel or reinforce each other, with the brighter, closer light producing the dominant shadow. This can give the effect of a shadow edge within a shadow, which makes part of the shadow lighter (fig. 9—4).

FIGURE 9—4

An illuminated shadow has a single dark edge, but its interior is lighter. This happens when light from an illuminated surface bounces back into a shadow area, carrying with it the color of the reflecting surface (fig. 9–5).

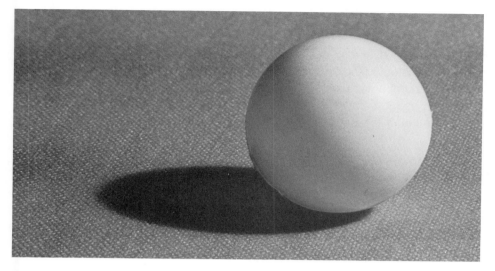

FIGURE 9–5

You will become more aware of these phenomena as you observe them further, and drawing them is the best way to learn to see them.

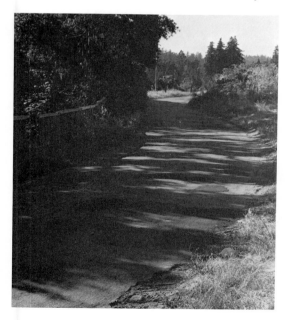

FIGURE 9–6

Shadow Shapes

Many shadows are so complicated that it is inconvenient to find them by any mechanical means; they are drawn "by eye." However it is well to remember that outdoor shadows are changing constantly; during the time it takes to complete your drawing, the shadow pattern may change considerably. Therefore, many artists make a small sketch of shadow patterns before they start in order to keep shadows consistent in the finished work. If you add new forms or rearrange existing forms, remember to make their shadows agree with the rest of the composition. For this purpose it is important to know how to find the correct shadow shapes; methods for finding them follow, but first here are some definitions and determining factors.

Definitions

Shading refers to the darkening of a form on the side not illuminated by the light source.

Cast Shadow refers to the darkening of a surface where another form or plane is interrupting the light source.

Illuminated Profile refers to the edge of the illumination on a form; it is where the shading starts. The shadow is cast from this edge.

In figure 9–7 identify the shading, cast shadow, and the illuminated profile. Answers are at the end of the chapter.

FIGURE 9–7

Determining Factors

1. *The shape of the form casting the shadow* determines the shape of the illuminated profile.
2. *The direction of the light source* in relation to the form and to the viewer determines the location of the illuminated profile on the form and the direction and length of the shadow.
3. *The shape of the surface on which the shadow falls*: the cast shadow takes the shape of the surface on which it falls.
4. *The nearness of the light source*: the closer the light source is to the form, the more the shadow will radiate from the form. Natural light is from the sun, and its rays are considered parallel.

CASTING A SHADOW

The shape and location of a cast shadow is found by drawing a vertical line from the illuminated profile to the ground plane below it. The light direction line goes through the top of the vertical, and the shadow direction line goes through its base. They intersect at the shadow edge. Such a vertical may be drawn at any point along the illuminated profile, but one *must* be drawn wherever the illuminated profile changes direction.

Shadow Direction and Length

Imagine yourself in an open area on a sunny day. There is a pole casting a shadow. You can walk around the pole and view it from any direction. If the shadow is horizontal, you can feel the sun on the side of your face; the light rays are parallel to the picture plane, which is like the front plane of your face. If you face the pole from another position, looking toward the sun, the shadow is cast forward toward you. If you go to the opposite side with the sun at your back, the shadow is cast back away from you. During these few minutes you have seen the shadow in several positions because you have changed your view of it; there has been no perceptible change in the shadow itself. Over a period of an hour or more, there would be a perceptible change in the shadow direction and length. Early or late in the day, shadows are longest; at midday, they are shortest.

If the light direction is vertical (at the 12 o'clock position) the sun is at its zenith (directly overhead), and no shadow is cast unless by an overhang. Rarely is the sun seen at its zenith since this condition depends not only on time of day but also on season of the year and geographic location (fig. 9–8).

FIGURE 9—8

Shadows Cast by Verticals

There are three general types, or shadow directions, cast by a vertical:

1. *Horizontal shadow*: The shadow is cast horizontally to the side; the sun is shining on the side of your face. Light rays are parallel to the picture plane and are drawn parallel to each other. All shadow direction lines are horizontal. See figure 9–9.

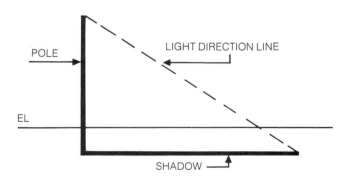

FIGURE 9—9

2. *Shadow cast forward*: The shadow is cast toward you; you are facing the sun. When it is cast forward and to the right or left, it is called an angled shadow. The shadow cast by a vertical recedes to a shadow vanishing point on the eye level, labeled VSVP to indicate that it is a vanishing point for a shadow cast by a vertical. The light rays are still parallel to each other, but now they are receding to a light vanishing point labeled LVP. It is located vertically above the VSVP. See figure 9–10.

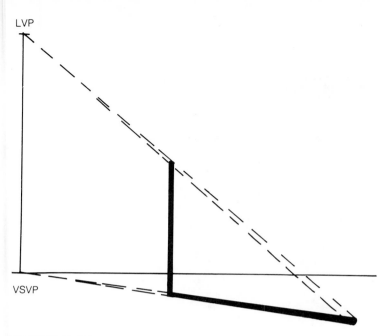

LVP

VSVP

FIGURE 9–10

3. *Shadow cast back*: The shadow is cast away from you; the sun is shining on your back. When a shadow is cast back and to the right or left, it is called an angled shadow. The VSVP is on the eye level, but the LVP is vertically *below* it instead of being above it, and both are placed on the shadow side. *This does not mean that the sun is below the horizon line (HL). It is the equivalent of the sun light coming over your shoulder on the opposite side.* See figure 9–11.

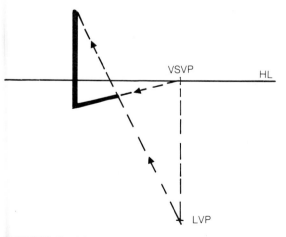

VSVP HL

LVP

FIGURE 9–11

In these photos (figs. 9–12 and 9–13) is the LVP on the right or left? Is the VSVP above or below it? Answers are below each figure.

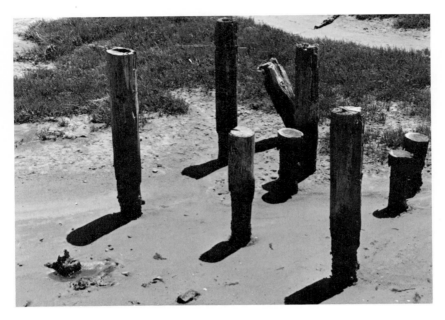

FIGURE 9–12

The LVP is on the right and the VSVP is vertically below it.

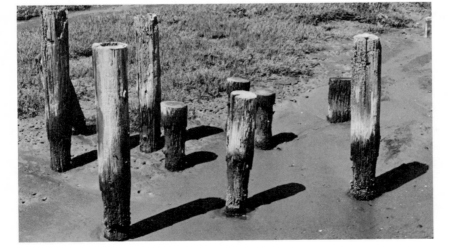

FIGURE 9–13

The LVP is on the right and the VSVP is vertically above it.

Shadows Cast by Horizontals

Shadows cast by horizontal edges on the form will recede to the same vanishing point used for corresponding edges of the form. If horizontals on the form do not recede, neither will their cast shadow edges.

DRAWING SHADOWS

Horizontal Shadows

Figure 9–14 shows a box casting a horizontal shadow because the light is parallel to the picture plane. All light direction lines are parallel to each other no matter what angle you choose, and all shadow direction lines are horizontal. This means that a vertical drawn from any point on the illuminated profile to the ground plane will cast a horizontal shadow from its base. You may cast as many verticals as you wish, but you *must* cast a vertical wherever the plane changes direction as it does at each corner of this box.

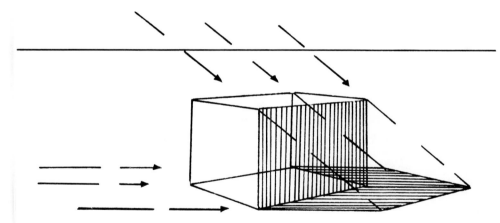

FIGURE 9–14

1. Draw a box in two-point perspective below eye level. Show hidden edges.
2. From the top of each vertical that is a corner on the illuminated profile draw a light direction line toward the ground plane.
3. From the base of each of these verticals draw a horizontal shadow direction line to intersect its light direction line.
4. Connect the points of intersection and return the shadow edge to the base of the box on both sides of the illuminated profile.
5. Darken the cast shadow and the shaded sides of the box.

6. Note that the verticals on the illuminated profile have cast horizontal shadows but that the receding horizontal edges on the illuminated profile have cast shadow edges receding to the same VPs as the corresponding edges of the form.

CHECKLIST

1. Are all light direction lines parallel?
2. Are all shadow direction lines cast by verticals horizontal?
3. Do all connecting edges go to the same VPs as the form?

Now draw a box in one-point perspective with a horizontal shadow. Only one side will be shaded; darken it and the cast shadow. Use the checklist above.

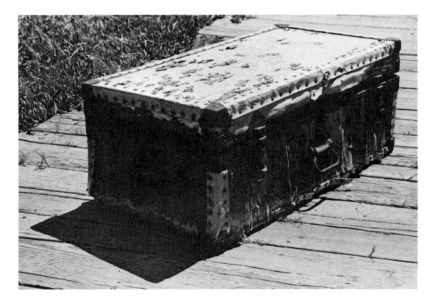

FIGURE 9–15

Shadows Cast Forward

One Side Shaded Figure 9–17 shows a shadow cast forward. Here the VSVP and the VP for the form are the same. This does not happen often, but when it does, only one side of the form is shaded. This is true of two-point perspective as well as one point. Draw a box in one-point perspective with the shadow cast forward and only one side shaded. See figure 9–16.

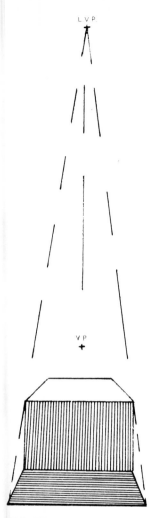

FIGURE 9—16

Two point:

1. Now draw box below eye level in two point.
2. Place the LVP vertically above one of the VPs.
3. The VSVP is now on the selected VP.
4. Continue as before by drawing the light direction lines from the LVP through the top of each vertical and beyond.
5. Draw the shadow direction lines form the VSVP through the base of each vertical and continue it to intersect the light direction line.

6. Connect the intersection points and darken the shaded area and cast shadow. Again, only one side of the box is shaded.
7. The shadow cast by the receding horizontal on the illuminated profile recedes to the corresponding VP of the form. Figure 9–17 is an example.

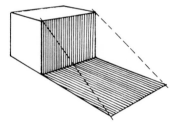

FIGURE 9–17

Angled Shadows Two sides will be shaded when the VSVP is not on a VP used for the form. Draw a box in one point with an angled shadow cast forward. Figure 9–18 is an example.

One Point

1. Draw a box in one point below eye level.
2. Place the VSVP on the HL but not on the VP.
3. Place the LVP vertically above it.
4. This shadow will be cast forward and to the side away from the LVP.
5. Two sides will be shaded, so three verticals will cast the shadow. Therefore it will be necessary to locate the base of the hidden back vertical on the shaded side.

190

6. Cast the shadow as before.
7. The receding horizontal shadow will go to the VP.
8. Darken the shaded area and the cast shadow.

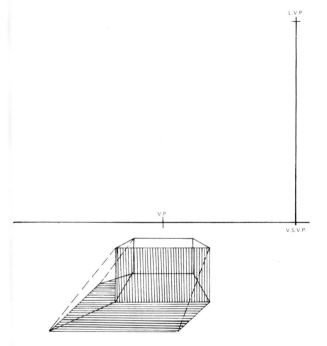

L.V.P.

V.P

V.S.V.P.

FIGURE 9–18

Two point:

1. Now draw a box in two point below eye level.
2. Place the VSVP on the horizon line but not on a VP.
3. Place the LVP vertically above it.
4. The shadow will be cast forward and to the side away from the LVP.
5. Two sides will be shaded, so three verticals are required. Cast the shadow from all three.
6. The receding horizontals will cast shadows receding the VPs.
7. Darken the shaded area and cast shadow. Figure 9–19 is an example.

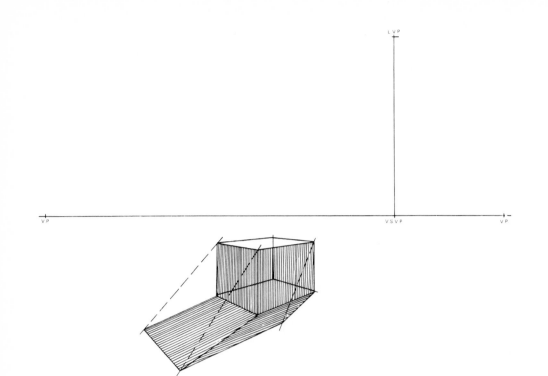

LVP

VP VSVP VP

FIGURE 9–19

Shadows Cast Back

As mentioned earlier, when the shadow is cast back, the light vanishing point and vertical shadow vanishing point are *on the shadow side*. The vertical shadow vanishing point is on the horizon line, and the light vanishing point is vertically *below* it; the farther it is from the horizon line (whether above or below) the shorter the shadow will be. Figure 9–20 is an example.

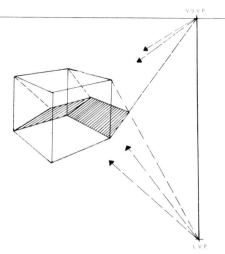

FIGURE 9–20

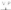

1. Draw a box in one point, two sides shaded, with the shadow cast back.
2. Draw a box in two point, two sides shaded, with the shadow cast back.

Remember to cast all verticals on the illuminated profile, even if they are hidden. Darken the shaded sides and cast shadows.

The Wedge

When casting the shadow of the wedge, cast the two verticals, then connect them to the wedge base corner without a vertical on the shaded side. Figure 9–21 and 9–22 are examples.

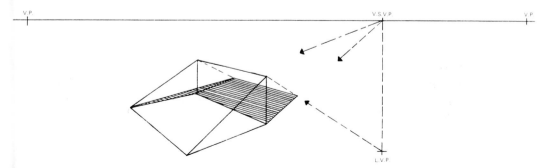

FIGURE 9–21

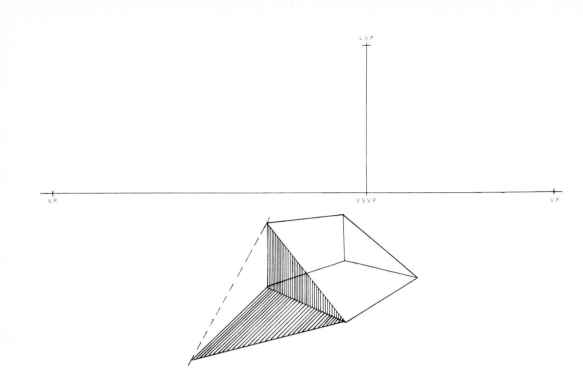

FIGURE 9–22

One Side Shaded In figure 9–22 you will see that it is possible to have only one side of the wedge shaded when the vertical shadow vanishing point is not on a vanishing point. This happens when one of the potentially shaded sides is the slanted top. Draw a wedge in one point with a horizontal shadow. Then draw a wedge in one point and a wedge in two point; cast the shadow back for one of them and forward for the other. *Remember that the shadow direction is the direction cast by a vertical.*

Shadows Cast on an Irregular Surface

When a shadow is cast on an irregular surface it follows the contour of that surface. The light direction lines remain constant, but the shadow direction lines change as the surface changes. To draw them, start at the base of the form casting the shadow. Here are some examples to draw.

194

FIGURE 9–23

In figure 9–24 the building is casting a horizontal shadow on a vertical wall. The outlined continuation of the shadow shows where it would fall if the wall were not there. The shadow is drawn from the base of the building casting the shadow to the base of the wall, then vertically up until it intersects the light direction lines.

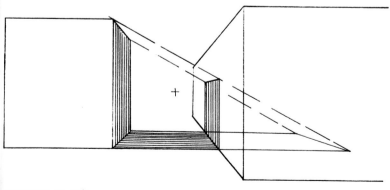

FIGURE 9–24

Drawn in the same way, the shadow in figure 9–25 is interrupted by a slanted plane.

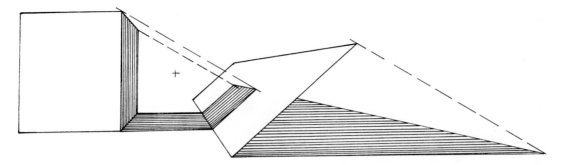

FIGURE 9–25

Figure 9–26 shows an angled shadow cast on a flat then vertical plane.

LVP

VSVP

VP

FIGURE 9–26

A horizontal shadow cast on a rounded surface is shown in figure 9–27.

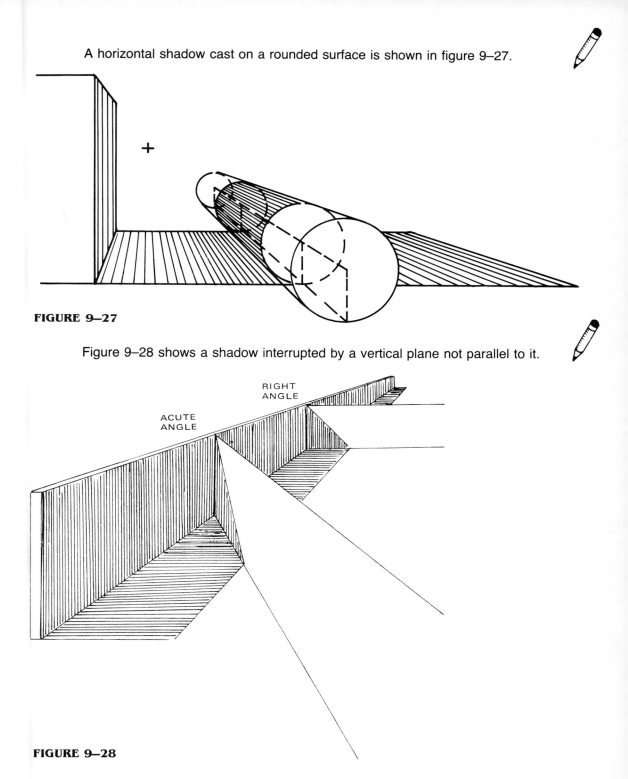

FIGURE 9–27

Figure 9–28 shows a shadow interrupted by a vertical plane not parallel to it.

RIGHT
ANGLE

ACUTE
ANGLE

FIGURE 9–28

Shadows Cast on an Elevated Surface

Figures 9–29 and 9–30 show shadows falling on a horizontal elevated surface. The procedure for finding the shadow follows each example.

One Point Draw this building in one point, figure 9–29, with an angled shadow, flat, then vertical, then flat:

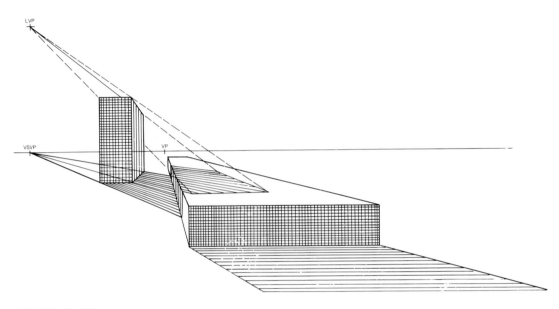

FIGURE 9–29

1. Draw the building and VP. Label corners to be cast on the illuminated profile *A*, *B*, and *C*.
2. Draw a curb receding to the same vanishing point. It will be parallel to the receding side of the building.
3. Place VSVP and LVP vertically above.
4. Draw the cast shadow as though it were flat. Here, in figure 9–29, "*a*" falls on the flat surface, but "*b*" falls on the elevated surface. Since *AB* is horizontal, it will cast a horizontal shadow to the base of the curb.
5. To locate "*b*" on the elevated plane, draw the ground line from VSVP through base of *B* to the base of the curb, then vertically to the top of the curb; then continue from VSVP to intersect line through *B* from LVP.

6. From "*b*" to the elevated edge is a horizontal. Connect this edge point with the horizontal from "*a*" at the base of the curb below.
7. Draw "*c*" the same way as "*b*" and connect them.
8. Complete the shadow with a line from "*c*" to the base of "*C*."

Two point Now draw this building in two point, figure 9–30, with an angled shadow, flat, then vertical, then flat:

FIGURE 9–30

1. Draw the structures.
2. Draw the shadow flat.
3. To reposition "*c*" on the elevated surface;
 a. Where line from VSVP touches base of elevation, go up vertically because both the edge casting the shadow and the curb are vertical.
 b. From the top edge of the vertical, draw a line from VSVP to intersect the light direction. Elevated "*c*" is positioned.
4. Find the VP governing the interrupted line.
5. Draw forward from the VP through "*c*" to the elevation edge. Connect this line with the shadow edge where it was interrupted by the elevation.

Several Levels Now draw a horizontal shadow on several levels: a flat surface that then goes down a steep slope, across a road, up a curb, and across a sidewalk.

FIGURE 9–31

Interior Shadows

Shadows are cast on the interior of an open form in the same way as on any other irregular surface; the light direction remains the same, but the shadow direction changes as the surface changes. When you are unsure where the shadow falls, draw it first as though it were falling on a flat surface; the change in the surface direction is seen at the edge of the shadow. Draw an open box with interior shadow cast forward or back. Here are two examples:

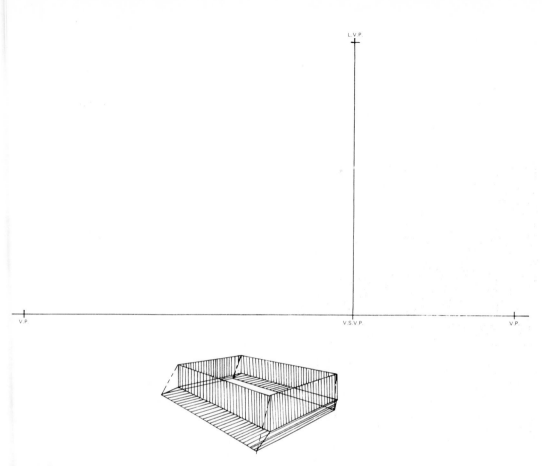

FIGURE 9—32

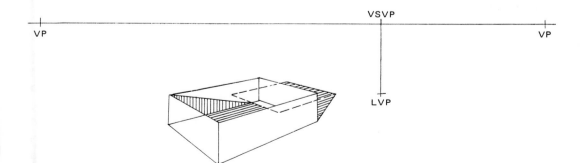

FIGURE 9—33

201

Shadows Cast by Forms Above the Surface

Frequently shadows are cast by a form or part of a form above the surface. This could be an overhanging branch of a tree, the eaves of a building, the cross arm of a power pole, a pedestal table top, or a ball on the surface or in midair.

FIGURE 9–34

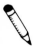

In these instances the cast shadow can be very important in placing the form in space and clarifying its size and shape in relation to other forms. One very simple procedure will locate the shadow: *From the illuminated profile above the surface, draw a vertical to the point on the surface directly under it.* This is called a *base point*. The shadow can then be cast in the same way as other verticals in the drawing; use the base point on the surface as the base of the vertical. Figure 9–35 is an example.

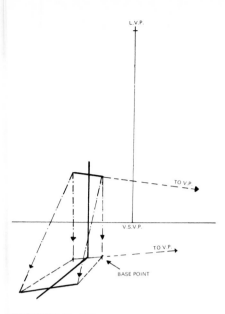

FIGURE 9–35

Draw a simple building with eaves overhanging on at least one side. Shade two sides of the building and cast the shadow forward. Figure 9–37 is an example.

1. Draw the building and establish a base point for each change of direction on the roof.
2. Establish LVP and VSVP.
3. Cast each corner of the roof and connect them. See figure 9–36.

FIGURE 9–36

4. Connect the roof shadow to the base of the building by drawing the eave shadow to the VP used for the eave, which intersects a line from VSVP through the corner of the building.

5. The shadow cast by the sloping roof on the far end is found in the same way used for the slanted side of a wedge: cast the high vertical and connect it to the low end. Here the high vertical is the peak of the roof on the back side. The low end of the slope is the corner of the eave on the back right. A line connecting these is interrupted by the shadow of the vertical corner of the building, back right.

6. Darken shading and cast shadow.

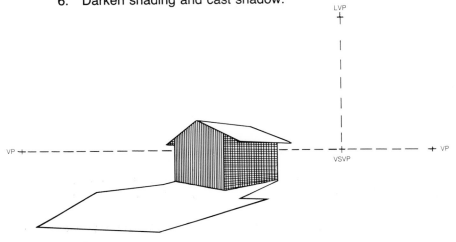

FIGURE 9–37

Shadows Cast by Cylindrical Forms

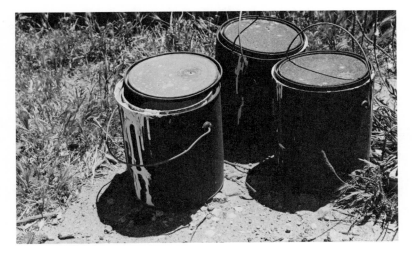

FIGURE 9–38

204

Natural light illuminates exactly half of the cylinder; therefore the illuminated profile runs the length of the cylinder on exactly opposite sides. These straight lengths cast shadow edges similar to the straight edges of a box. They are connected by the elliptical shadow edge cast by the round top.

The Cylinder on End To draw the ellipses of the standing cylinder accurately, draw the cylinder in a square-ended box seen in one point perspective with the vanishing point vertically above its center (fig. 9–39).

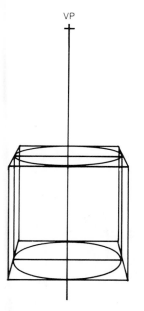

FIGURE 9–39

1. To cast the shadow, first locate either the LVP and VSVP or the illuminated profile, whichever is more convenient. Note that the illuminated profile goes through the circle center, not the ellipse center. The shadow direction is a line tangent to the base of the illuminated profile from the VSVP on the HL. The LVP is vertically above or below it (fig. 9–40).
2. Next, cast the shadow for the two vertical sides of the illuminated profile with a line from the LVP through the top of each vertical side intersecting a line from the VSVP through the base of each.
3. Now select several convenient points on the curved top of the illuminated profile and extend verticals to the base of the cylinder. Cast these additional verticals and connect their intersection points with a curving line. The shadow is outlined; darken it and shade the cylinder. Now draw a cylinder on end with shadow cast back. Then draw a cylinder on end with a horizontal shadow.

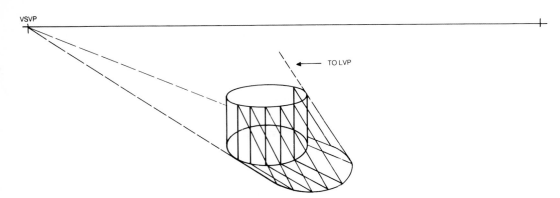

VSVP

TO LVP

FIGURE 9—40

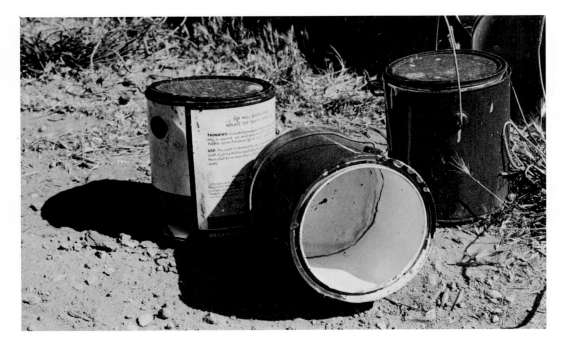

FIGURE 9—41

The Cylinder on its Side The cylinder on its side may be drawn freehand, or a template may be used for drawing the ellipses. This is the procedure for drawing a cylinder on its side using an ellipse template:

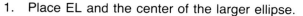

Using a Template

1. Place EL and the center of the larger ellipse.
2. Place the VPs.
3. Draw a line from the ellipse center location to a VP. This will be the center core of the cylinder.
4. Select an ellipse degree suitable for its placement in relation to EL and CV, and draw the ellipse with its minor axis on the cylinder center core line.
5. Draw a line from the top and bottom of the major axis to the same VP.
6. Select a smaller ellipse of the same degree and place it so that it touches the top and bottom lines to the VP and its minor axis is on the center line. The cylinder is complete (fig. 9–42).

A: CONTACT LINE
B: BASE POINT LINES

FIGURE 9–42

Drawing the Shadow

1. Draw the cylinder on its side, making sure that the minor axes of the ellipses are continuations of the center length of the cylinder.
2. Draw a vertical through each ellipse center to find the point where it touches the surface. This is *not* the major axis of the ellipse. Connect these two contact points with a line going to the VP. This is your contact line.
3. Through the touch point at each end draw a tangent to the ellipse and extend it to a second VP. Base points for the ellipses will be on these lines vertically under selected points on the illuminated profile.
4. Locate the VSVP and LVP. As in figure 9–43, cast the shadow from conveniently established verticals on the cylinder end. Note the vertical which casts the shadow farthest from the cylinder. Draw a line from the top of this vertical along the cylinder side toward the VP. This is the side illuminated profile. Cast the opposite end of the cylinder.
5. Darken the shaded area and cast shadow, figure 9–44.

LVP
+

VSVP
+

FIGURE 9–43

FIGURE 9–44

Figures 9–43 and 9–44 show an angled shadow. When casting a horizontal shadow, the cylinder is drawn and the base points found in the same way. Remember that for a horizontal shadow, all shadow direction lines are horizontal and all light direction lines are parallel to each other. Therefore there is no LVP and VSVP. Figures 9–45 and 9–46 show this.

208

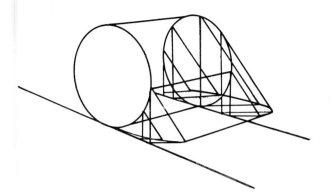

FIGURE 9—45

FIGURE 9—46

Draw a cylinder on its side with a horizontal shadow, as shown in figure 9–46,

1. A line from one of the VPs within a 60-degree angle of vision will be the center core of the cylinder.
2. Draw the large ellipse with its minor axis on the center core. In choosing the ellipse degree remember to consider its position and distance from EL and CV.
3. Draw lines tangent to the top and bottom of the ellipse going to the same VP as the core line. Within these three lines fit a smaller ellipse of the same degree with its minor axis on the center line. The cylinder is complete.
4. To cast its shadow, draw a tangent from the base of each ellipse to the second VP. These will be the base point lines for the ellipse ends.
5. Select convenient points on the ellipse and draw verticals from them to the base point lines. Draw a horizontal from the base of each.

209

6. Connect the top of each vertical with the horizontal from its base using parallel light direction lines. Connect the intersection points with a curving line.

Now

1. Draw a cylinder on its side with its shadow cast forward.
2. Draw a cylinder on its side with its shadow cast back.
3. Draw a cylinder on its side with its shadow cast horizontally.

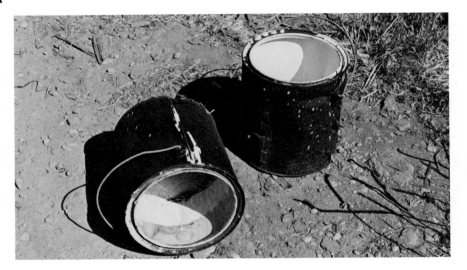

FIGURE 9—47

The Open Cylinder When a standing cylinder is open, a shadow is cast inside it on the curved inner surface. The diameter establishing the illuminated profile is unchanged. Half of the top ellipse is the illuminated profile for the exterior shadow as before; the other half casts the interior shadow. To find the interior shadow,

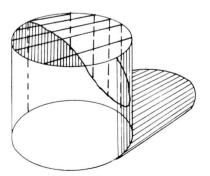

FIGURE 9—48

210

1. Select several convenient points on the illuminated profile which is the half ellipse closer to the light source (fig. 9–48).
2. Through each draw a shadow direction line from the VSVP and continue it to the opposite side of the rim.
3. From each of these points a line is drawn vertically down the side of the cylinder.
4. Draw a light direction line from the LVP through each point which is casting the shadow, intersecting its corresponding vertical on the opposite side.
5. Connect the intersecting points with a curved line, bringing it to the top at the illuminated profile diameter.
6. Darken the shadow.

Figure 9–49 shows several shaded cylinders. Draw their interior shadows. Answers are at the end of the chapter.

V.S.V.P.
+

+
L.V.P.

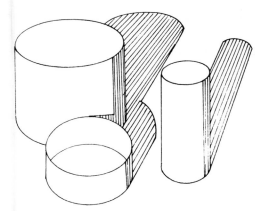

FIGURE 9–49

Shadows Cast by Cones

FIGURE 9—50

Cones cast a great variety of shadow shapes of a flat surface, according to their position and the light direction. The simplest of these shadows is cast by the cone on its base.

The Cone on Its Base When it is necessary to place the cone accurately in space, it may be done as with the cylinder by drawing it in a square-ended box. The tip is at the center of one end. The cone has only one vertical through which to cast the light direction and the shadow direction; this is the vertical from the tip to the center of the base. To find its shadow,

1. Draw the cone and its illuminated profile, which is a straight line from tip to base along its side. If the shadow is horizontal, the illuminated profile will be in the center; if the shadow is angled, it will be off center.
2. Locate the hidden base of the illuminated profile on the far side with a line from the base of the illuminated profile on the near side through the center of the base.
3. Locate the VSVP by drawing a tangent to the base of the illuminated profile and extending it back to the horizon line. The LVP is vertically above it.
4. Cast the shadow of the cone tip with a light direction line from the LVP through the tip and beyond, and a line from the VSVP through the center of the base to intersect it.

5. Connect this point with both sides of the illuminated profile at its base.
6. Darken the shadow (Fig. 9–51).

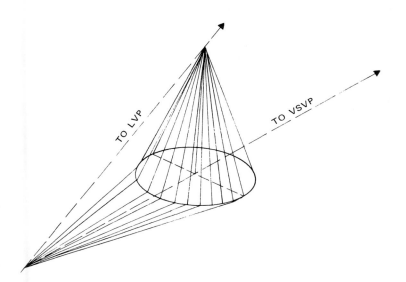

FIGURE 9–51

Now

1. Draw the cone on its base with a horizontal shadow.
2. Draw the cone on its base with a shadow cast forward.
3. Draw the cone on its base with a shadow cast back.

The Cone on Its Tip　To cast the shadow of the cone on its tip, proceed as with the cone on its base, reversing its position. Now the ellipse of the cone casts a shadow, so draw it the same way as the top ellipse of the cylinder. Base points are located on a base ellipse vertically under the top rim.

Remember that the shadow direction is tangent to the illuminated profile at its base point on the base ellipse. As with the cone on its base, the shadow direction is not a shadow edge; the cast ellipse returns to the point of the cone on both sides. Figure 9–52 is an example.

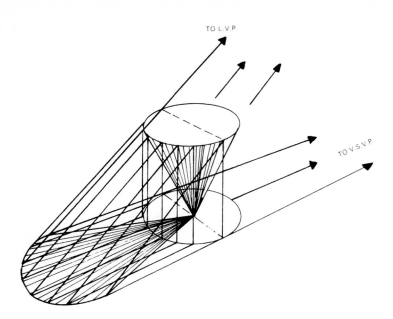

FIGURE 9–52

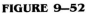

Now

1. Draw a cone on its tip casting its shadow forward.
2. Draw a cone on its tip casting its shadow back.
3. Draw a cone on its tip casting a horizontal shadow.

The Cone on Its Side This is a difficult form to place accurately because the face of the cone is not vertical in this position; it is slanted back at the top toward the tip, at an angle equal to one-half of the angle at the cone tip (fig. 9–53). Seen in side view it can be measured, but in other views the slant is usually estimated.

FIGURE 9–53

214

Placing the Cone

If you prefer to calculate it exactly, draw the cone in a square-ended box in two point perspective with its tip centered at one end. Using the lower edge of the face end of the box as a hinge, submerge the opposite end of the box halfway into the surface. The cone side is then touching the surface, and the face is at the correct angle. These are the steps to follow:

1. Draw a square-ended box in two point perspective (fig. 9–54).

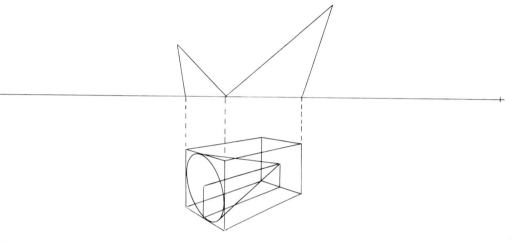

FIGURE 9–54

2. Draw a line through the center of both square ends and extend it to the VP. This is the cone center line.
3. The cone face ellipse touches all sides of one square end with its minor axis on this line. The cone tip is at the center of the opposite end. Draw the cone.
4. Draw a line vertically under the cone center line to the same VP to locate the center length of the bottom of the box. This will be the *contact line* when the box is submerged and the cone length is touching the surface.
5. The cone contact line will be slightly longer than the box length. To find it, measure the distance from the contact point on the cone face to the cone tip. Extend the box center line to this length and place the tip.
6. Draw a line from the cone face center through the new tip location on the contact line and extend this line to a slanted plane VP vertically under the eye level VP.
7. Redraw the cone face ellipse with it minor axis on this line. Complete the re-positioned cone (fig. 9–55).

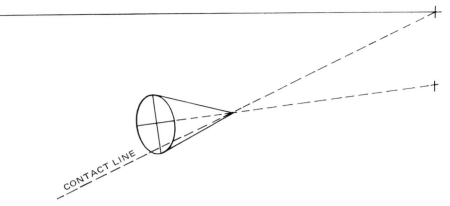

FIGURE 9–55

Drawing the Shadow

1. To find the base point ellipse vertically under the now slanted face of the cone, first draw a line on the cone face from the contact line through the face center to the top, then draw verticals from the center and top to the contact line (fig. 9–56). These verticals establish the base point ellipse center and its minor axis on the contact line.

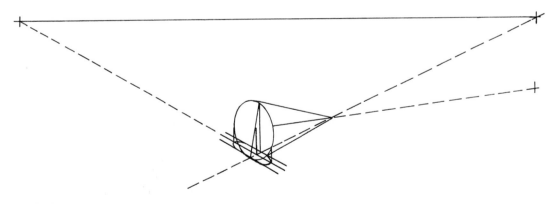

FIGURE 9–56

2. The base point ellipse center will be on the contact line vertically under the face center. To find its major axis, draw a line from the face VP through the base point ellipse center. The major axis is on this line. It length is limited by verticals tangent to each side of the cone face.

3. Draw lines parallel to the major axis through the face contact point and the point on the contact line vertically under the face top. The minor axis of the base point ellipse is limited by these lines.

4. Draw the base point ellipse.
5. Establish the LVP and VSVP and cast the shadow. You will find that verticals from the top half of the face end on the back of the base point ellipse, those from the bottom half end on the front.
6. To find the illuminated profile on the length of the cone, cast the entire end. Then draw a line from the cone tip tangent to the shadow. Trace this tangent point to its source on the illuminated profile. Draw a line on the cone from this point to the tip.
7. Darken the shaded area and the cast shadow (fig. 9–57).

FIGURE 9–57

Now

1. Draw a cone on its side below eye level with its shadow cast forward.
2. Draw a cone on its side below eye level with its shadow cast back.
3. Draw a cone on its side below eye level with its shadow cast horizontally.

Cone Sections A cone section, or tapered cylinder, is drawn in the same way as the cone except that its smaller end is a smaller circle, usually seen as an ellipse. To cast its shadow use the same method as for the cone.

Interior Cone Shadows: The Cup A cone section may be open at one end or both; a paper cup is a good example. Often the open end casts a shadow on the cup's interior.

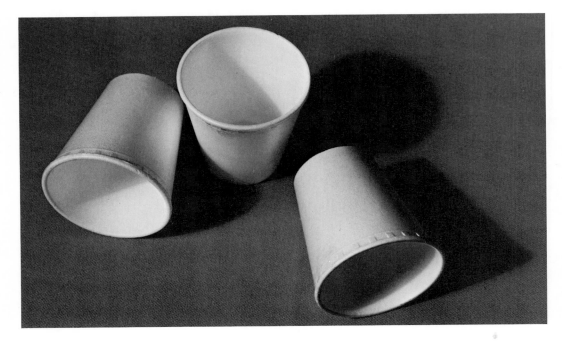

FIGURE 9–58

To find the interior shadow use the same principle as for shadows cast on the interior of the cylinder: The light direction remains the same, but the shadow direction changes as the direction of the surface changes.

Draw a paper cup upright on a flat surface, casting its shadow back and to the right, and draw its interior shadow.

First, draw the cup:

1. *Top*: Draw a cylinder in a box as in figure 9–59. The top ellipse will be the top rim of the cup, and the lower ellipse will be its base point ellipse.
2. *Bottom*: Choose a smaller ellipse of the same degree as the base point ellipse. Draw it within the base point ellipse matching its center and axes.

218

FIGURE 9-59

3. *Sides*: Connect the top to the bottom of the cup and continue the sides down
 to meet at a cone tip centered below the cup.

FIGURE 9-60

219

Prepare to cast the shadow:

1. Establish the LVP, VSVP, and the edges of the illuminated profile at the top.
2. Draw the illuminated profile down both sides of the cup toward a cone point centered below, stopping at the bottom of the cup.

Cast the outside shadow in the same way as for the cone, returning the shadow to the base of the cup at the illuminated profile on each side, figure 9–61.

FIGURE 9–61

Cast the interior shadow in the same way as for the open cylinder, except that lines going down the interior wall will not be vertical. Instead, they will be drawn toward the cone point, figure 9–62. Here are directions.

FIGURE 9–62

220

1. Select several convenient casting points along the illuminated half of the top rim. Draw a line through each point toward the VSVP, stopping at the opposite side of the rim, then down the interior side of the cup toward the cone point.

2. Now draw a line from each casting point toward the LVP. It will intersect the shadow direction line drawn from the same point, determining the shape of the shadow.

3. Connect the intersection points with a curved line, being sure to return it to the illuminated profile at the top. Plot the entire shadow, though much of it may be hidden.

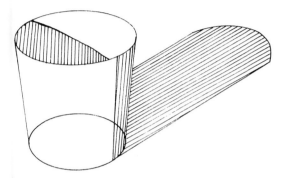

FIGURE 9–63

The Sphere

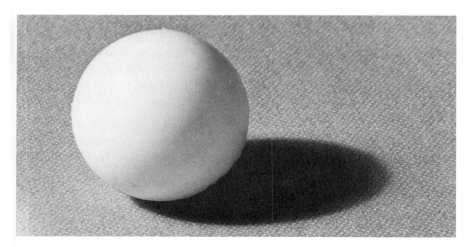

FIGURE 9–64

The sphere is seen as a circle from any view, so its shading and cast shadow are the principal clues to its three-dimensional form and to its position in space.

Locating the Sphere

1. Draw a circle and locate its center at the intersection of its vertical and horizontal diameters. The center of the sphere will be seen as the center of the circle from any position.
2. Locate the sphere in space by establishing eye level, VP centered above the sphere, and SP.
3. If the sphere is resting on the ground plane, it will be vertically above a square with its touch point at the center of the square. If it is airborne, draw a vertical from its center to the ground plane and draw the perspective square on the ground plane to establish its position in relation to other objects in the drawing.

FIGURE 9—65

Shading the Sphere Exactly half the sphere is shaded, so its illuminated profile is a circle, usually seen as an ellipse. It is seen as a straight line only when the light direction is parallel to the picture plane and when the circle center or an extension of it goes through the CV; it is seen as a complete circle only when the sun is centered directly in front of it or behind it.

The minor axis of the ellipse is on the light direction line; the major axis goes through the center at a right angle to the minor axis.

1. Locate the LVP.
2. Draw a line from the LVP through the center of the sphere.

3. Draw the ellipse with its minor axis on this line. This ellipse is the illuminated profile. If the sun is coming from behind the sphere, the shadow is cast forward and you see more than half of the shaded side; if the shadow is cast back, you see less than half of it (fig. 9–65).

The Shadow Shape

The only time a sphere casts a perfect circle shadow on the ground plane is when the sun is at zenith; the light rays are perpendicular to the ground plane, and the ground plane is parallel to the illuminated profile. The degree to which these planes are not parallel and/or the light rays not perpendicular is the degree to which the circle shadow is stretched into an ellipselike shape.

To locate the shadow shape, project it from base points vertically under the illuminated profile. These form a base point ellipse centered around the touch point.

Locating the Touch Point

1. Draw a line from the SP to the sphere center.
2. Draw a second line from the center, below the first and perpendicular to it.
3. At the point where the second line intersects the sphere, draw a horizontal to the sphere's vertical diameter. This is the touch point (fig. 9–66).

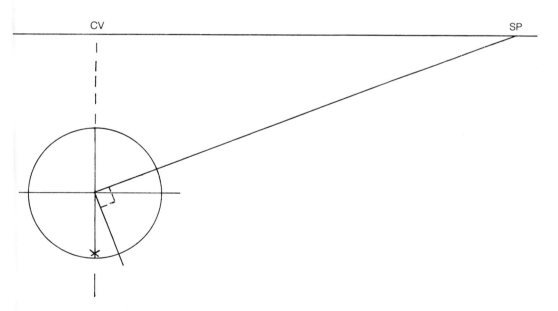

FIGURE 9–66

223

FIGURE 9—67

Figure 9–67 is an example.

1. Draw a horizontal through the touch point. This will be the circle center behind the major axis of the base point ellipse.
2. To limit its length, draw verticals tangent to the outside limits of the illuminated profile at right and left and bring these down to the touch point horizontal.
3. To limit its depth subtract the length of the illuminated profile minor axis from the length of the major axis. Center the remaining length on the touch point horizontal.
4. Draw lines from its ends forward and back to the VP to intersect a diagonal from the SP.
5. At intersection points, draw horizontals limiting the base point ellipse depth.
6. Draw the base point ellipse within this foreshortened square.

FIGURE 9–68

Figure 9–68 is an example

1. Select several convenient points on the illuminated profile and draw a vertical from each to its base point on the base point ellipse.
2. Through each selected point on the illuminated profile draw a line from the LVP and extend it beyond the sphere.
3. Draw a line from the VSVP through each selected base point and extend it beyond the sphere to intersect a corresponding line from the LVP. Remember to cast the back of the illuminated profile from the back of the base point ellipse, the front from the front.
4. Connect the intersection points with a curving line to establish the shadow.
5. Darken the shadow and shade the sphere.

Now draw a sphere above the surface. Remember that the base point ellipse will be on the surface directly under the sphere, but the shadow will not be vertically below unless the sun is at its zenith. The center of the base point ellipse is located where the touch point would be if the sphere were touching the surface. Draw the shadow so that no part of it is hidden by the sphere. Remember to keep the shadow within the 60-degree angle of vision to avoid distortion.

ARTIFICIAL LIGHT

Artificial light rays are not parallel; they radiate from a point at the center of the light source. The closer the light source is to the form casting the shadow, the more the shadow fans out from the form.

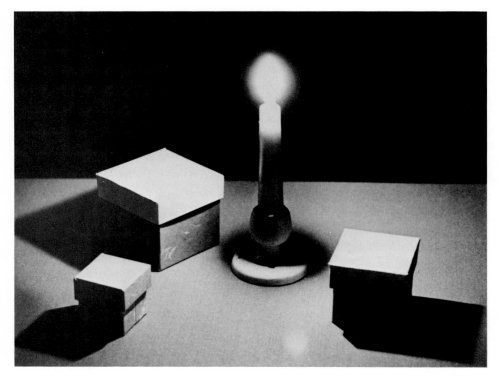

FIGURE 9—69

To draw the shadow cast by artificial light, the same method is used as for natural light except that

1. The light source can be in any position, even below the form.
2. The VSVP is on the surface vertically under the light source, not on the HL. It locates the position of the light in space.

226

Placing the Light Source

The higher the light source is in relation to the form, the shorter the shadow will be. When the light source is below the top of the form, the shadow, or part of it, is cast up; it is clearly seen only on a surface opposite the light source—perhaps a wall or ceiling.

Placing the Vertical Shadow Vanishing Point

The vertical shadow vanishing point is vertically under the light vanishing point on the surface. A horizontal through it locates the light source distance in space: if it is in front of the form, the shadow is cast back; if it is in back of the form, the shadow is cast forward. See figure 9–70.

Drawing the Shadow

Cast the shadow as previously:

1. From the LVP draw a line through the top of each vertical and extend it beyond.
2. From the VSVP draw a line through the base of each vertical to intersect the light direction line.
3. Connect these points to determine the shadow. When correctly drawn, all shadow edges cast by verticals of the form recede to the VSVP, and all shadow edges cast by horizontals of the form recede to the same VP as those of the form. This method is used for all forms.

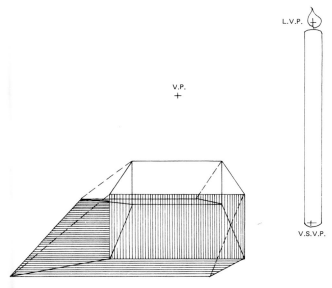

FIGURE 9–70

Draw several forms arranged around an artificial light source located above the tops of the forms. Darken their shaded sides and cast shadows. Now draw a box with an artificial light source below its top, casting its shadow on a wall. Darken shaded sides of the box and the cast shadow. Remember that when the shadow reaches the wall it changes its direction to the vertical of the wall. Figure 9–71 is an example.

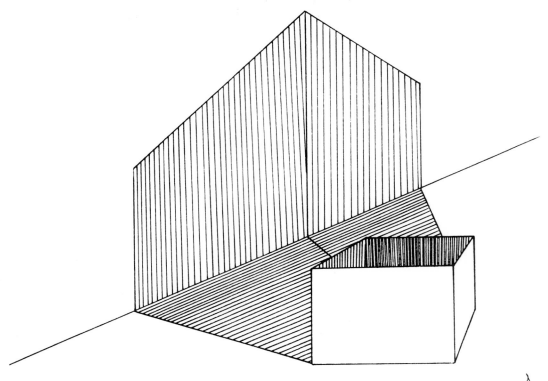

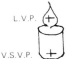

L.V.P.

V.S.V.P.

FIGURE 9–71

228

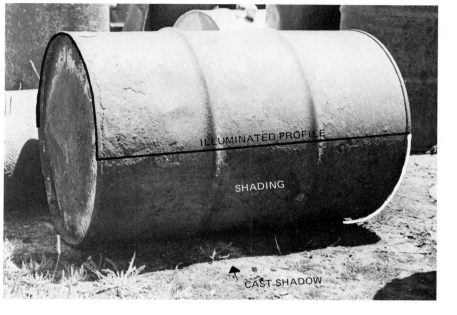

FIGURE 9—72 Answer to self-test, Figure 9—7

FIGURE 9—73 Answer to self-test, Figure 9—49

reflections

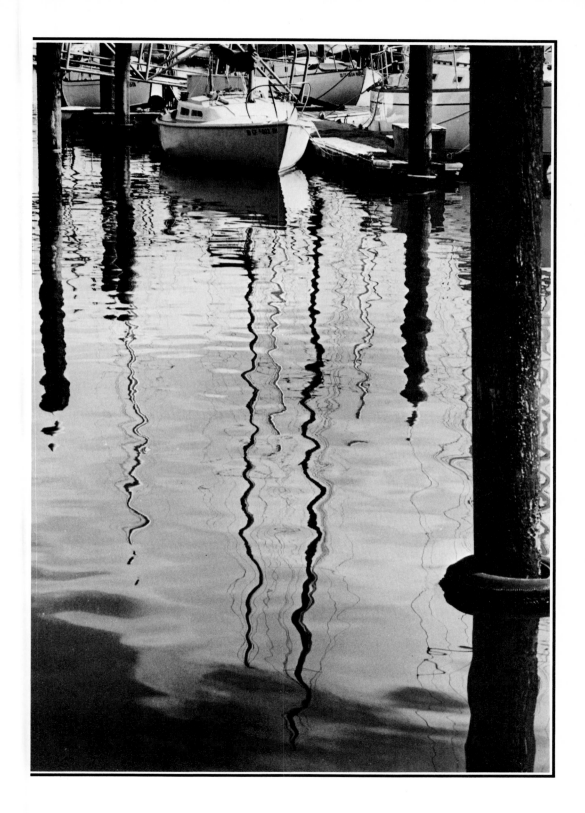

FUNCTIONS OF REFLECTIONS

Reflections add richness to visual perception and stimulate imagination by showing new possibilities of form and arrangement.

Multiple Images

The size of a room can be visibly doubled by surfacing one wall with mirror, or multiple images and infinite distance may be created with mirrors on opposite walls.

One image may be superimposed on another as seen in a store window when a parked car reflection is superimposed on goods for sale with the store. A still pond may reflect sky and trees superimposed on fish swimming just below the surface.

Distortion

Any reflecting surface which is not absolutely smooth and flat will distort the reflection. This is most obvious in water. When the surface is very still, undisturbed by wind or water currents, the reflection is clear and perfect. But if there is a ripple

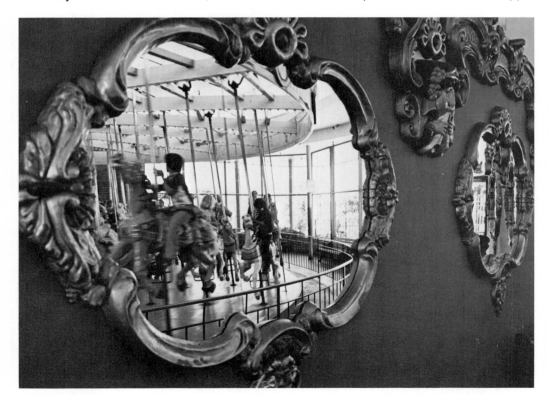

FIGURE 10–1

on the water, the image is broken or distorted as in figure 10–3; straight edges appear wavy or broken by slivers of reflected light. Irregularly curved reflecting

FIGURE 10–2

surfaces are the basis of fun house "mirrors" in which you see your own form stretched and contracted in strange ways, changing as you move. The side of a

FIGURE 10–3

glass bottle or tumbler can show a rectangular window light source as a curved rectangle. All these experiences show us that the distortion of a reflected image indicates the texture and shape of the reflecting surface.

Revealing Hidden Form

A convex mirror, functioning in a manner similar to a wide-angle lens is often used as a surveillance measure in stores to allow a wide area to be seen from a single point. This mirror is not a modern invention; we have evidence of similar metal mirrors being used in homes five centuries ago, probably as an ornament or religious object. Today flat mirrors on adjustable mounts are used to reveal other hidden shapes as do rear view mirrors on a car or the mirror used by the dentist to see the back of your teeth.

DRAWING REFLECTIONS

When drawing reflections, particularly those distorted by a curved surface (fig. 10–2), draw directly from the source if possible, but in doing this be very careful that your station point remains constant. Even a slight movement of your head makes a considerable difference in the perceived reflection. For this reason a thumbnail sketch or a photo reference may be helpful when doing an extended study involving reflections. In this chapter, we will work with flat reflecting surfaces in several positions.

PRINCIPLES GOVERNING REFLECTIONS

1. The angle of incidence equals the angle of reflection.
2. The distance of incidence equals the distance of reflection.
3. The reflected image is reversed.
4. The size is constant.

This means that what goes in comes out at an equal angle and at an equal distance from the reflecting surface. The image is reversed, and the size of the reflection is consistent with its perceived placement in distance.

FIGURE 10—4

When the reflecting surface is horizontal, as a mirror table top or water in a landscape, the image is reflected down. A vertical above the surface continues as a vertical reflection below the surface. The angle of incidence is 90 degrees, and the angle of reflection is 90 degrees, totaling 180 degrees or a straight line. The reflected image will measure the same as the object reflected, and its distance from the surface will measure the same. The reflection will be governed by the same vanishing points as the object reflected, and the image will be reversed.

Block on Surface

Place a child's alphabet block on a mirror surface and draw it. Draw the reflection the same size and governed by the same VP or VPs. Note that letter images are reversed; the part of the letter closest to the surface on the block remains closest to the surface in the reflection. Refer to figure 10–5.

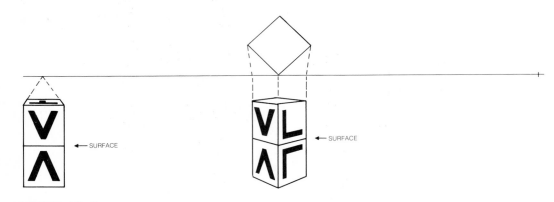
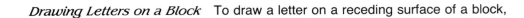

FIGURE 10–5

Drawing Letters on a Block To draw a letter on a receding surface of a block,

1. Measure the border, the stroke width, and the center. Place these measurements on the closest vertical or horizontal edge.
2. On receding sides, draw crossing diagonals.
3. Receding measurements are drawn as horizontals toward the VP and may change direction to become vertical at the diagonal.

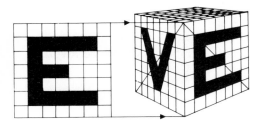

FIGURE 10–6

Block Above a Surface

Now place a second block on top of the first one. Tape a piece of tracing paper over your drawing. On the tracing paper draw the second block and its reflection. Show all four corners where the first block touched the surface. Your drawing will show a block held above the surface. The bottom surface of the block previously hidden is now seen as the top surface in the reflection. Show the reflected letter reversed. Use the checklist for the previous drawing.

FIGURE 10–7

This method of calculating reflections applies to any form. Figures 10–8 and 10–9 show a pole sticking out of the water at a slant.

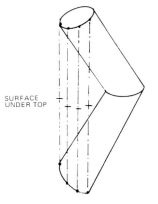

FIGURE 10—8 LEANING BACK

FIGURE 10—9 LEANING FORWARD

Drawing a Landscape

In landscape, when the object being reflected is on land, it is higher than the reflecting water surface; the land is holding it above water level. To locate its reflection, first find the water level vertically below it. This locates the form in distance. A flat plane grid may be helpful for this purpose. Draw verticals from the object profile to the water surface beneath, and continue them repeating the measurements in the reflection. To find the reflection of the moon in water, use the

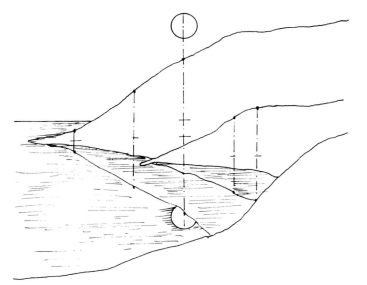

FIGURE 10—10

238

horizon line as surface. You will find that close forms and their reflections some-
times hide reflections of forms farther away. The landscape in figure 10–10 shows
how this works. Draw a landscape. Include calm water, moon, some natural forms,
and some man-made forms reflected in the water. Show a variety of distances with
some reflections hidden by closer forms and their reflections. Show surface points.

IMAGES REFLECTED TO THE SIDE

Block and Ball

FIGURE 10–11

When a mirror is vertical and perpendicular to the picture plane, it recedes to a
one-point VP and reflects an image to the side of the object. If a block is placed
parallel to the mirror, the reflection is on a horizontal line extended to the side. The
distance from each corner to the mirror surface is repeated beyond the mirror
surface. As found in other reflections, parts of the form may be hidden in the
reflection, other parts revealed. See figure 10–12. Draw an alphabet block in one-
point perspective parallel to a vertical mirror at one side. Draw a ball next to the
block on the side away from the mirror. Draw the reflections. Show the mirror
surface points. Be sure the SP is far enough from the VP to place the objects and
their reflections within a 60-degree angle of vision.

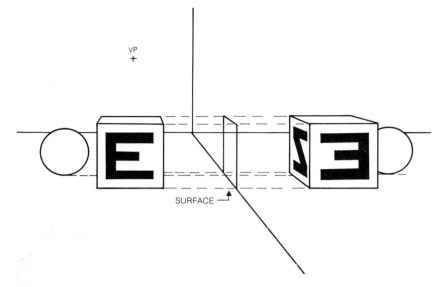

VP
+

SURFACE

FIGURE 10–12

IMAGES REFLECTED BACK

Projecting from a Plan View

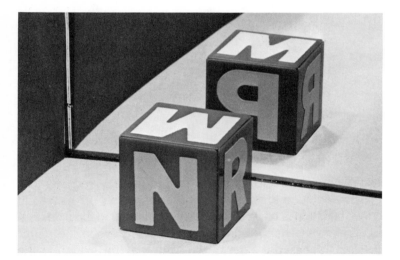

FIGURE 10–13

A vertical mirror in back of a form reflects the image back. This gives a reflection smaller than the reflecting form, as though it were placed farther away. To draw its

distance and size accurately, use a plan view of the form, the mirror, and the reflection. In the plan view the reflection is drawn as though it were a solid form on the opposite side of the mirror.

Block and Mirror Parallel

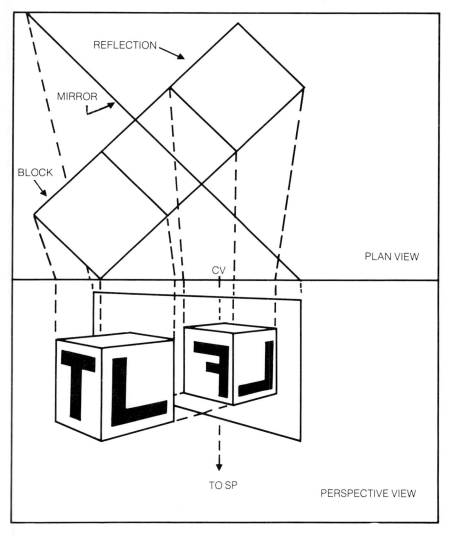

FIGURE 10–14

Two Point In figure 10–14 the mirror is vertical, so the plan view shows it as a single line. Here the block is parallel to the mirror, so the block and its reflection use the same VPs. Draw a similar one of your own. Show letters on at least two sides of the reflection. Here is the procedure:

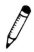

1. Draw the plan view, SP, and VPs.
2. Draw the block in perspective.
3. Draw the mirror, base first.
4. Draw the reflection.

One Point Figure 10–15 shows a block, mirror, and picture plane all parallel, producing one-point perspective. Draw a similar block. Include letters on at least two sides of the block and the reflection.

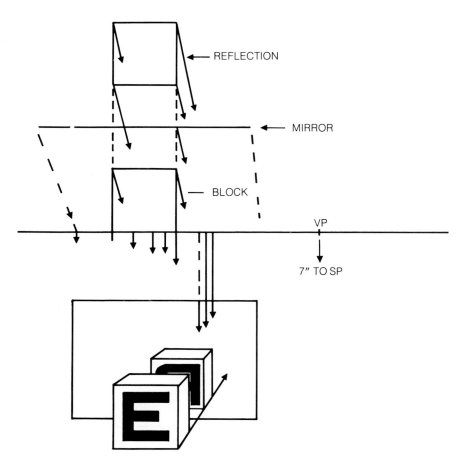

FIGURE 10–15

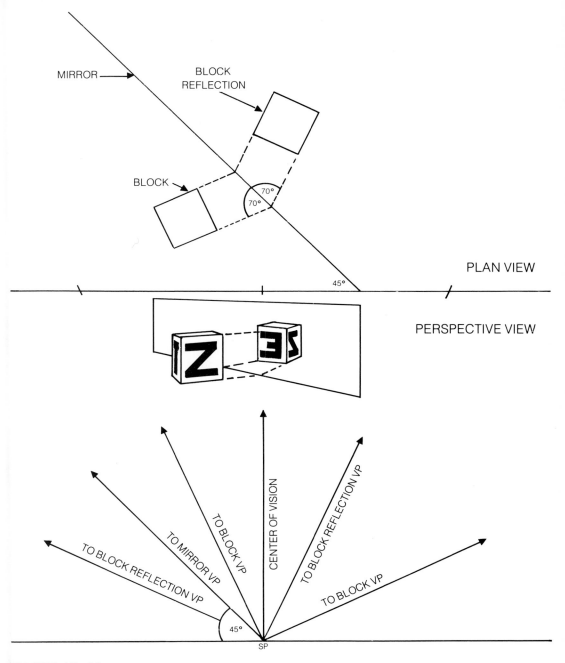

FIGURE 10–16

Figure 10–16 shows a block in two-point perspective not parallel to an angled mirror. In the plan view the sides of the block are extended to the mirror and contact the mirror at an angle of 70 degrees. This is the angle of incidence for the side of the block. The angle of reflection, therefore, must also be 70 degrees. The distance of incidence and the distance of reflection must also be equal; thus, their measurements are the same in the plan view. Briefly, the process for drawing this block, mirror, and reflection is

1. Draw the plan view.
2. Locate reference points: SP and VPs.
3. Draw the block by projection.
4. Draw the mirror, base first.
5. Draw the reflection.

Here are the expanded directions for figure 10–16. Draw one of your own similar to this.

1. *Draw a plan view* of a block, mirror, and reflection. Place the block plan with its sides not parallel to the picture plane. Place the mirror at an angle not parallel to either the block or the picture plane. Draw the plan of the reflection the same size as the block, extending lines from each corner of the block across the mirror perpendicular to its surface. Measure the distance from each corner to the mirror and repeat this distance beyond the mirror to locate the corresponding corner of the reflection. An alternate method is to continue the receding sides of the block until they touch the mirror. Measure the angle between this line and the mirror; then repeat it on the other side, continuing the line in its now changed direction. Often both of these methods are used in order to check accuracy.

2. *Locate reference points*: Establish the center line of vision and SP. Locate VPs for block, mirror, reflection and direction of the incidence by drawing lines parallel to their sides from SP. Note that the block and the reflection are not parallel in the plan, so they will have separate sets of VPs.

3. *Draw the block* by projecting it down from the plan view. If the closest corner of the block in the plan view touches the picture plane, the closest height of the block measures the same as a side of the block in the plan.

4. *Draw the mirror.* To place the mirror extend it in the plan view if necessary to a point horizontal with the front of the block; here, it is the picture plane. Draw the base first to the mirror VP.

5. *Draw the reflection* as though it were a solid block placed in distance behind the mirror. Project it down from the plan view as with the first block. Its distance in space is located with a line from each corner of the first block toward the VP for the direction of incidence intersecting verticals projected down from the plan. Complete the block and its reflection with letters on at least two sides of each. Remember to reverse letters on the reflection.

SUMMARY

Reflections add visual excitement and information to drawings and paintings. They are often rendered directly from the subject, but change greatly with a slight change of view. These principles govern reflections:

1. The angle of incidence equals the angle of reflection.
2. The distance of incidence equals the distance of reflection.
3. The reflected image is reversed.
4. The size is constant.

The sizes of form and reflection are equal, but when the image is reflected back, the reflection is seen as smaller, as though it were placed at a farther distance. In the reflection the image is reversed in much the same way as the right hand is a *mirror image* of the left.

conclusion

You have drawn one-point, two-point, and three-point perspective, flat surfaces and slanted surfaces, with rectilinear forms aligned in a single direction or several directions. You have drawn circles, cones, and domes in perspective and have learned how to properly proportion and position objects and people in a drawing, their shadows and reflections.

Many drawings are done while viewing the subject, but the artist rarely makes an exact copy of what is seen—often it is a simplification or a rearrangement, and many drawings are done entirely from memory or imagination. In any of these cases, if you wish to present a convincing view of the visual world, these perspective drawing skills should help you.

Find a view of your world that excites you, and draw it. Draw the general shapes first, quickly and lightly. This will transmit your feeling. Then check your drawing for perspective accuracy, making corrections where needed. Remember to draw the correct line before erasing the incorrect line. Then bring your drawing to the desired degree of completion, taking care not to destroy the original feeling. Shading where appropriate will enhance the expression. The more you draw, the more you will enjoy it!